THE END OF CELLULOID

Published and distributed by

RotoVision SA
Route Suisse 9
CH-1295 Mies
Switzerland

RotoVision SA
Sales, Editorial & Production Office
Sheridan House
112/116A Western Road
Hove BN3 1DD, UK

Tel: +44 (0)1273 72 72 68
Fax: +44 (0)1273 72 72 69

Email: sales@rotovision.com
Web: www.rotovision.com

10 9 8 7 6 5 4 3 2 1
ISBN: 2-88046-783-7

Edited by Leonie Taylor
Designed by Studio Tonne
Email: studio@studiotonne.com

Reprographics in Singapore by ProVision Pte Ltd.
Tel: +65 6334 7720
Fax: +65 6334 7721

Printing and binding in Singapore by ProVision Pte Ltd

FOR LCBT

THE END OF CELLULOID
FILM FUTURES IN THE DIGITAL AGE

MATT HANSON

RotoVision

THE END OF CELLULOID
FILM FUTURES IN THE DIGITAL AGE

INTRODUCTION
FROM REALITY TO ILLUSION 07

01
CAPTURING THE UNNATURAL
SUPERNATURAL, PSYCHOLOGICAL, AND EVERYDAY HORROR 13

02
RECORDING REALITY
THE DIGITAL REVITALIZATION OF DOCUMENTARIES 27

03
THE NEXT LEVEL
COMPUTER GAME-INFLUENCED REALITIES IN FILM 41

04
PLAYER VS. SPECTATOR
GAME AS CINEMA, FMV, CINEMATICS, AND MACHINIMA 55

05
THE DARK CORNER
DIGITAL VISIONS ON THE MARGINS 69

06
ACCELERATED CINEMA
THE INFLUENCE OF MUSIC VIDEO DIRECTION 83

07
QUICK ON THE DRAW
THE RISE OF ANIMATION 97

08
THE ETERNAL GAZE
THE FUTURE OF AUDIOVISUAL CONSUMPTION 115

09
ACTING UNREAL 123
PART 1: **EGOLESS STARS** 124
PART 2: **RELIVING HISTORY** 132

10
DOUBLE VISION
FILMMAKING FOR FUN AND PROFIT 141

11
AGAINST THE GRAIN
BEYOND VIDEO ART—FILM AS FINE ART 151

12
RETURN OF THE EPIC
CINEMA'S LAST STAND 163

SELECTED FURTHER READING/VIEWING/PLAYING 172
FINAL CREDITS 173
GLOSSARY 174
INDEX 175

INTRODUCTION
FROM REALITY TO ILLUSION

linear del juego y explore 'ejados, gocé de los anuncios del siglo pasado y ev... 'oblemas con los demás.

...ios El IU", me hice un skin de turista canadiense y v... 'el mundo del Grand Theft Auto III. No

.. detallados están producidos cómo su, 'ducto de la industria del juego de video. Cat

This book is not about film. Not simply about what we see on screens and monitors. Not just about watching, alone in the dark or together with friends. This is, fundamentally, a book about how we can experience moving image now and in the future.

A century of cinema has passed, and as it has, so the torch has passed from Lumiére [i] to Méliès [ii], from realism to illusion. The way we are now able to modify and alter images means that everything from subtle irrealities to full-blown fantasy, intimate documentary, and devastating new forms of drama can be portrayed on screen. For the first time, if something can be imagined it can become a "film".

Between the hegemony of Hollywood moviemaking and arthouse alternatives, we are very rarely able to glimpse the way forward for cinema. The digitization of cinema means elements can be fused and altered by the processor, blurring the lines previously dividing these established schools and their traditions. The 800lb gorilla of moving image, the feature film, is increasingly coming under attack. It needs to shape up, mutate, and evolve if it is to stay relevant in a universe of changing hardware, content, and, ultimately, the thing that matters most: viewer expectations. This is an exceptional time of transition, offering an opportunity to create transformational works. More and more filmmakers are choosing to push their work in this direction.

The End of Celluloid examines the array of visions being realized, and the range of genuinely progressive cinematic works available. In researching this book, I found plenty of material concerned with film criticism, academic analysis, and technical manuals, but was astounded to discover no accessible commentary on this unique time for this dominant visual form. I hope that this book goes some way to putting this situation right. Cinema's time of transition presents a chance to blend the younger digital arts with 100 years of moving image: a period of flux in which to create new forms of filmmaking that are between experimental and current mainstream ways of seeing.

In 1988, I read a book called Dictionary of the Khazars. The author, Milorad Pavic, labeled it a "lexicon novel"; a series of interweaving fables, stories, and tales made up as dictionary entries. This "hypernovel" was an early form of hypertext, with which many of us are now familiar as the universal navigation system of the Internet. The richness and sense of discovery I found in this non-linear way of telling stories fundamentally changed the way I looked at the medium, and how I have looked at all media since. I have been a film critic and have created a pioneering digital film festival in search of a similar discovery in moving image [iii]. I haven't found that monumental breakthrough just yet, but the works featured in this book give me confidence that it is just around the corner.

How do you rebel against an invasion of an increasingly uniform vision, of a world of double whammies, three-act structures, and happy endings that you can predict from the opening scene? Established filmmakers are finding spaces within current entertainment structures, through new uses of technology, and opportunities afforded by DVD and other digital distribution. Other moving imagemakers outside these structures are creating visual experiences through computer games, and by discovering alternative avenues through "nanotainment" and micro-movies.

Viewers are responding to these new choices because they still want to be lost in a story, to be surprised, and to be entertained. The safe commercial formulas are breaking down, as current genres have become over-familiar and tired. The old media giants are fighting back by gambling on a new breed of spectaculars and blockbuster movies. Time will shortly tell whether this is a band-aid applied to a gaping wound or if they can adjust quickly enough to engage with the new narrative worlds that are non-linear, emergent, and extensible.
>>>

Over a century, cinema has neatly defined itself into genres—neat boxes of ideas. The U.S. Library of Congress helpfully lists these in the *Moving Image Genre-form Guide* [iv]. The fact that it was last updated in February 1998 gives some indication as to the usual rate of institutional response in keeping up with the pace of change. These genres, even specifically subdivided for experimental, advertising, and animation areas no longer feel adequate. This is, of course, in no small part due to the speeding up of creative advances stimulated by digital ways of working.

Essentially, film is steadily being superseded by a strata of digitally inflected moving image. "Digital video strikes me as a new platform wrapped in the language and mythology of an old platform," notes the novelist William Gibson. "Lamb dressed as mutton, somewhat in the way we think of our cellular systems as adjuncts of copper-wire telephony. The way we still 'dial' on touchpads. We call movies 'film,' but the celluloid's drying up." [v]

I see this strata of moving image emerging out of the basic forms of film and TV, as "advanced moving image". As it adapts to utilize contemporary digital technologies, hardware and software, existing descriptions become more problematic, less accurate, not adequately explanatory. The Innuit have several hundred words for snow, but in a global culture so profoundly captivated by motion pictures, we have astonishingly few to describe our modes of viewing, and these types of advanced moving image. *The End of Celluloid* suggests a start to the creation of a modern and accessible lexicon for this domain.

Digital video allows us the promise of truth in the image like never before; it conceals and reveals artifice at one and the same time, and holds the promise of myriad ways of seeing. Filmmaking in the digital age allows us all to create and experience fantasy worlds that are as real as the world we live in. It is for us each to decide whether these encounters with moving image are our own personal route to subjugation or sublimity. This is the paradox and pull of the form. Moving image is being morphed, bent, and warped along x, y, and z-axes. This is a book about what we deserve to see along these axes—its content serves as half-manifesto and half-user guide to the next era of filmmaking, and the rise of advanced moving image.

NB: Visit the book's accompanying website, www.endofcelluloid.com, for further interviews and additional links

SOURCES

[i] *Louis Lumiére with his brother, Auguste, invented modern filmmaking with the creation of the Cinématographe in 1895, popularizing the form with their early film documents such as Workers Leaving the Lumiére Factory, and Arrival of a Train in the same year*
[ii] *Georges Méliès was the father of film effects, pioneering the use of illusions and visual effects in his landmark films such as Le Voyage dans la Lune (1902)*
[iii] *onedotzero. See www.onedotzero.com*
[iv] *The Moving Image Genre-form Guide, Library of Congress, U.S. (2/1998)*
[v] *"William Gibson's Filmless Festival," William Gibson, Wired (10/1999)*

CAPTURING THE UNNATURAL
SUPERNATURAL, PSYCHOLOGICAL, AND EVERYDAY HORROR

Cinematic horror has always been at its eeriest and its most convincing when stripped down. The genre is at its best flayed of all pretensions or extraneous details— any hint, in fact, that what is happening has any root in artifice. This is why, together with porn, the horror genre has benefited most from consumer-grade digital video. This change in the equipment and the way the action can be filmed is the best thing to happen to horror since its groundbreaking origins. Inspired by an ever-increasing diet of TV reality shows shot quickly and cheaply, modern horror feels more convincing without art direction and without any trace of mediation. It becomes realer than real. You can almost smell the fear.

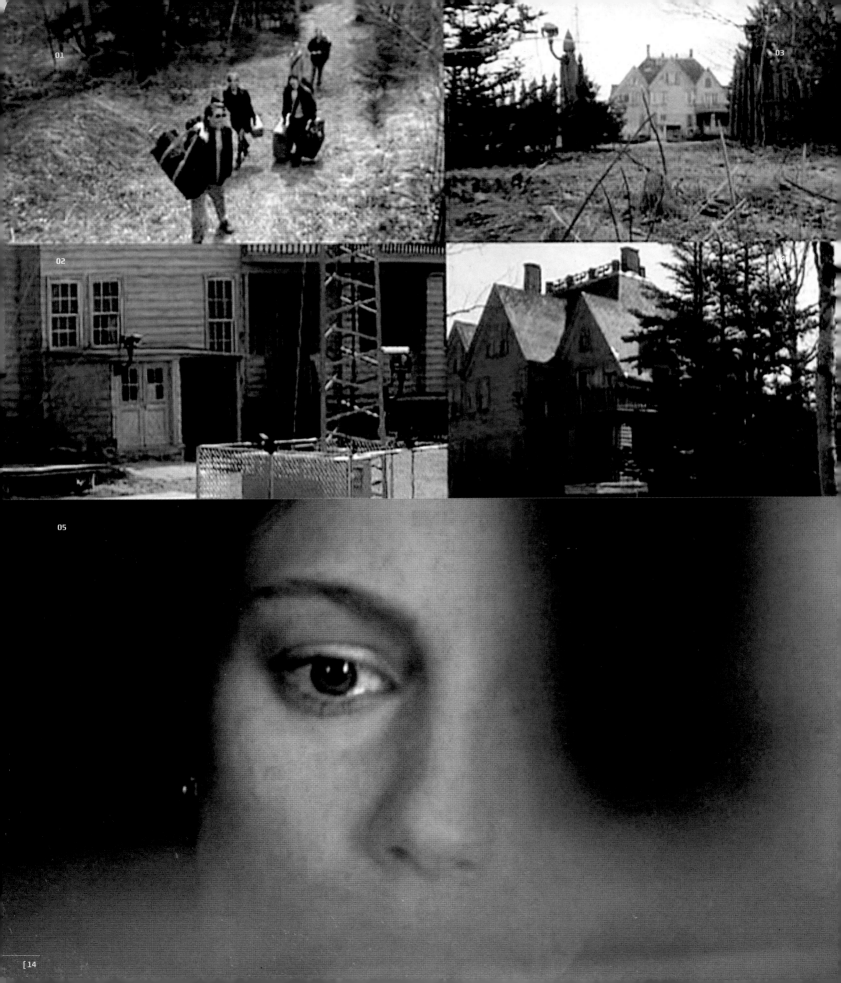

**FILM: MY LITTLE EYE
DIRECTOR: MARC EVANS
YEAR: 2002**

06

07

The sense of verisimilitude is what gives *My Little Eye* (2002), a web-cam-based horror film by director Marc Evans, its peculiar power. Described by him as an "exercise in unpleasantness," the film successfully translates a self-imposed limited filming grammar into a language of menace. By rigging a "haunted house" set with a bunch of digital video (DV) cameras obtainable from any shopping mall, Evans serves us a story that connects the danger to our everyday experiences, as most of us have some experience, if not of filming, then at least of watching home videos.

"It was constricting in that we couldn't move the cameras, but it was a deliberate choice. We wanted to dehumanize it, make it really sinister. All we did was little pans and zooms. We would tell the camera operator off if he started getting too smooth," says Evans. [i]

This enhances the all-encompassing feeling of surveillance. The film's premise is that a group of American teenagers have to live together in an isolated house for six months to win $1 million. Nobody can leave the house, otherwise they forfeit the prize, and footage from the house is streamed over the Internet so the occupants are monitored constantly.

"The idea was to give the feel of a live-vision mix. You don't see them [the website operator], you don't know who it is, but you feel that someone's in control. It was quite experimental, to see if we could use this language to tell the story," explains Evans.

Evans takes the scenario and sets out to deeply affect the look and feel of the film around it, to immerse the viewer in the situation: "With *My Little Eye*, the whole look and sound of the film came out of the texture of the digital world, especially as manifest on the Web. Artists like Bill Viola [see page 168] working in the digital field were an influence regarding the aesthetic, as were films like *The Blair Witch Project* [1999], of course. The look of digi-tape blown up onto 35mm film has an intrinsically beautiful quality. It reminded me of the grain that 16mm film would acquire when projected—grain that has been eliminated from 35mm in recent times due to technological advances. The grain of the film is part of its personality, and it seems to me that digital, though lacking the personality of film in some ways [as with music, the purists still prefer analog over digital for its imperfections and 'warmth'], seems to have an impure beauty when projected that is extremely attractive and easy to achieve. But really this is just the surface, because one could find other means of achieving this kind of degraded look."

Introducing the grammar of Internet "webisodes" and *Big Brother*-style reality TV refreshes the horror genre and reflects the contemporary in a similar way to genre predecessors that have reflected nuclear, apocalyptic, viral, and societal concerns. Most pertinently, the digital technology was used most appropriately for the story.
>>>

IMAGES

]01-05[*My Little Eye: haunted house as televised prison*
]06-07[*horror takes on reality TV trappings with camcorder interviews*

Evans elucidates: "Everybody says it about digital, but it was particularly true about our film. It broke down all those things, like hitting marks and focuses, especially for all these American actors who're very, very technical. They were complicit in the process; in the DIY, low-tech way we made the movie. When we were shooting the night vision stuff, there was only one way of shooting that—putting all the lights out and shooting in the dark, so they were acting in the dark, which made the experience a lot less mediated. There's such a palaver setting up any shot, especially if you're going to get into any action sequences or special effects, and this was the opposite of that." [ii]

Evans found that the technical changes have a knock-on effect on the mental approach to how the film is brought together: "Where digital has affected me more profoundly has been in the way that small cameras, that require less light and use cheap stock—tape being so much cheaper than film—allow you to shoot. The shot is no longer sacrosanct and precious, or so labor-intensive. You can try things without much setting up or worrying too much about budget.

"Added to this was the fact that *My Little Eye* was a multi-camera affair, so my approach became increasingly different. The way the whole thing was put together felt genuinely experimental and the extent of the experiment only became really clear during post-production—the amount of material and the rules we had set ourselves about how the story must be told. Everything had to be from the point of view of surveillance cameras, in the here and now, as it happened. In truth, much of the aesthetic of the film came out of the rules of the experiment and the experiment was only possible due to digital technology."

>>>

IMAGES

]01-03 [*My Little Eye: flipping between harsh camcorder lighting or night-vision shots imbues the recording with an authenticity that makes the terror more real and immediate*

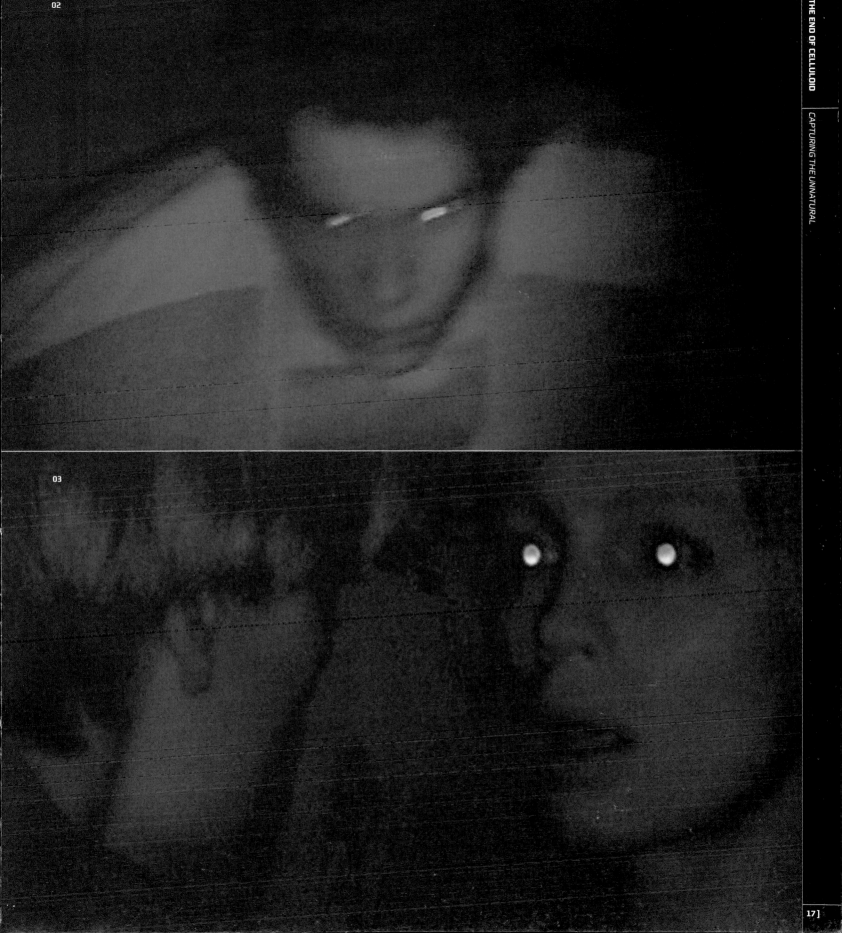

02

03

FILM: RINGU (THE RING)
DIRECTOR: HIDEO NAKATA
YEAR: 1998

The way digital video is used imbues the film with the power of found footage. Night vision in particular is an in-camera effect that has the sense of capturing the unnatural, of that which should not be seen. This sense of realism achieved through digital techniques is much more powerful: if you look at even the most horrifying scenes in conventional film—the discovery of a snuff movie in Joel Schumacher's *8mm* (1999), for example—they fail to unsettle in the same way as their digital counterparts, as the action can feel too polished, too perfectly staged. Compare this with the action in Tobe Hooper's *Texas Chainsaw Massacre* (1974), which increases its ability to chill over time as the years imprint it with authenticity.

The success of hit Japanese horror, *Ringu* (*The Ring*, 1998) is based on this same ability. Centered around a mysterious videotape that must be passed on if the viewer is to avoid being stricken by a curse and dying, *Ringu* creates an instant urban myth that fuses the paranormal and technological in a telling manner. A similar device has some great precedents in print [iii], but on film it's never been so powerful. While the majority of the film is shot in a highly effective but essentially traditional manner for its type, the script hit a nerve.

>>>

IMAGES

] 01-03 [*Ringu: degraded digital video is used to create the feeling of a taboo, paranormal artifact*

02

03

Sada

> **"The sound was important, and I underlaid several unsettling noises that added to the visuals"**
> HIDEO NAKATA

03

The uneasy feeling is coupled with director Hideo Nakata's clever use of grungy digital video effects to affect the cursed tape with authenticity—a factor that he acknowledges as key to the movie's success.

"The video was a major part of the *Ringu* production," explains Nakata. "In the book, it runs for 20 minutes and has a concrete story. I decided that it should not describe anything in solid terms, as it would play several times in the film. I felt that if it were too explanatory, it would become boring after repeated viewings. Only eight shots long, it took two days to shoot. I then spent 24 hours editing and processing it using computer effects. The sound was important, and I underlaid several unsettling noises that added to the visuals. The video in itself is not scary, but it's unnerving and leaves the audience feeling anxious." [iv]

The U.S. remake *The Ring* (2002), by Gore Verbinski, doesn't stray from this formula. The "found" video is the key element of the story that elevates it to urban myth and cult horror status. Verbinski explains: "I felt I wanted to go with this kind of dream logic. Everyone wants to find the answer, to feel that things are resolved. But in dreams maybe there isn't an answer so much. It's more about images and emotions, so I wanted to keep that kind of feel." [v]

>>>

IMAGES

] 01-03 [*Ringu: the degraded video quality suggests a malevolence that is complemented by the ambiguity and strangeness of the on-screen action*

FILM: 28 DAYS LATER
DIRECTOR: DANNY BOYLE
YEAR: 2002

In modern horror, what is unsaid, or only glimpsed, is more effective than the overstimulation of the slasher flicks of the 1980s and early 1990s. Digital video excels at providing an immediacy in atmosphere that is more subtle and unsettling than these earlier gorefests. The connection is reinforced through more personal recording methods that relate to our direct experiences. Danny Boyle takes such a tack in *28 Days Later* (2002) but allies it with a more visceral approach to the genre.

Boyle, director of *Trainspotting* (1996) and *The Beach* (2000), is adept at hitting hot button topics. These aren't picked by chance, but carefully chosen and analyzed, as he has elaborated: "With all the films that we've done, we try and take a genre and fuck with it a bit. It helps market the films, and the studios or whoever is distributing the film love that and it contacts a mainstream audience... Alex Garland [*28 Days Later* writer] is a big zombie fan. But also he's a big fan of the sci-fi writing of J. G. Ballard, *Day of the Triffids* [John Wyndham, 1951], and *The Omega Man* [film, 1971, based on Richard Matheson's novel *I Am Legend*, 1954]. We are not stealing, but nothing can stand on its own anymore—there is always some reference point. So, in a sense maybe, we do steal stuff and then try and put it together in a different way." [vi]
>>>

"So you kind of snatch at fast images, like falling rain or a man running, in a slightly unreliable way"

DANNY BOYLE

01

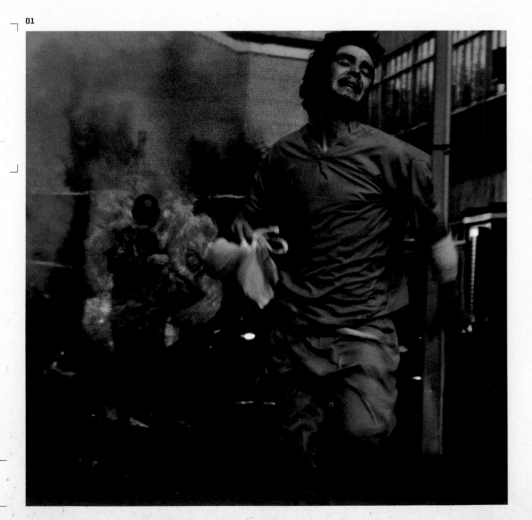

IMAGES

]01-02[*28 Days Later: digital video is adeptly used to snatch at nightmarish visions*

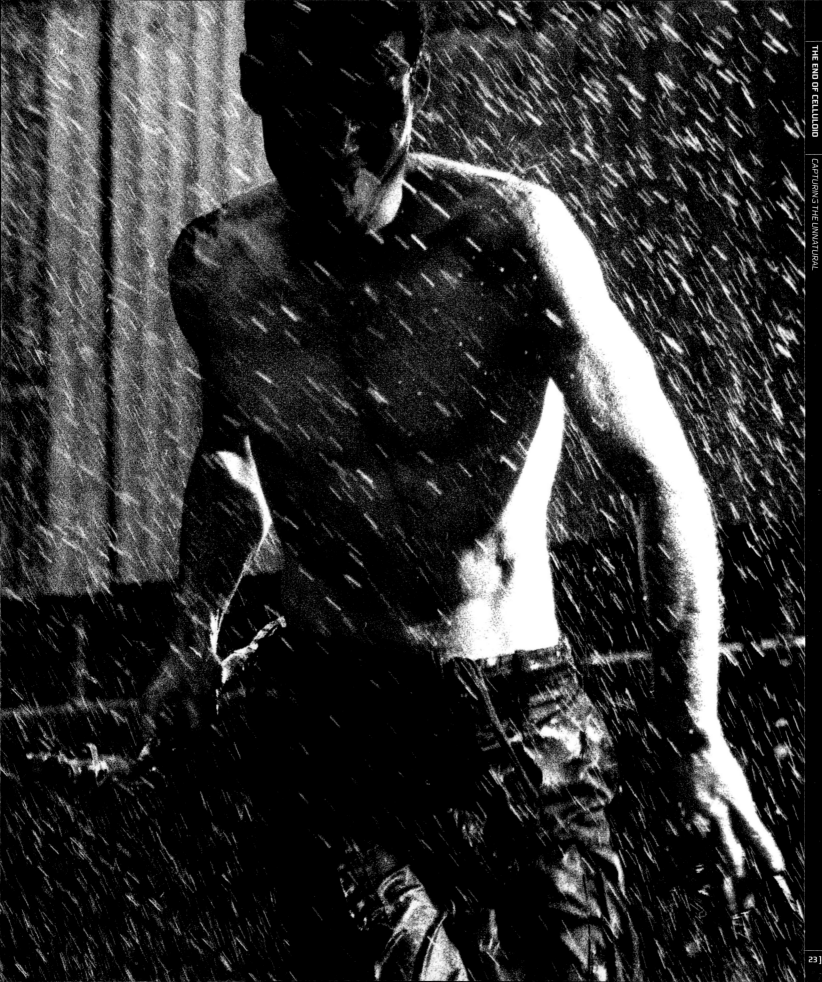

"We talked about having a different texture, which we got with the DV. We would tickle the color of the film occasionally to create a slightly strange universe"

DANNY BOYLE

28 Days Later takes place in a desolate Britain, devastated by a virus that infects humans with a rabid bloodlust. The infected are the modern-day equivalents of the zombies we know from *Day of the Dead* and other classics. The way they are depicted in DV keeps their humanity while instilling them with supranormal powers.

Boyle explains: "We wanted it to feel different in texture from normal film. Because it's an apocalypse, you can use a different hue, because nobody knows what things will look like if everybody's killed. So we talked about having a different texture, which we got with the DV. We would tickle the color of the film occasionally to create a slightly strange universe."

The film's director of photography, Anthony Dod Mantel, a DV specialist, provided this otherness through the digital medium.

Boyle continues: "I wanted this enormous energy from those who are infected, which I was going to get through this particular menu on the camera, which allows you to alter the frame rate; things appear to be speeded up but actually it's real time. So you kind of snatch at fast images, like falling rain or a man running, snatching at them in a slightly unreliable way. The idea is that you can't quite trust your usual sense of judgment about perception, depth, and distance when dealing with the infected. I was determined to do that, although there was quite a lot of opposition at one point as it was thought that it would make the film look very odd."

Digital video in horror allows a shorthand that gives the filmmaker a tool to short-circuit our initial skepticism of what is being portrayed on screen. By using the format's "ordinariness", it confounds the visual codes that offer the audience the comfort zone and escape clause that tells us this can't be real.

IMAGES

]01-02 [*28 Days Later: digital video shooting allows quick set-up time, allowing the filmmaker to capture an eerily empty, apocalyptic early-morning London*

SOURCES

[i] www.jigsawlounge.co.uk. Interview: Neil Young (2002)
[ii] www.Mymovies.net (2002)
[iii] *contempurary equivalents in fiction include: Pixel Juice: Cabinet of the Night, Jeff Noon (1998); Lullaby, Chuck Paluniak (2002)*
[iv] *Fangoria 200, Norman England*
[v] *Interview: Alana Lee, www.bbc.co.uk (2003)*
[vi] *Interview: Sandy Hunter, Res (2003)*

RECORDING REALITY
THE DIGITAL REVITALIZATION
OF DOCUMENTARIES

Filmmakers have used DV to create a renaissance in documentary production. Digital media has enabled them to document subcultures and experiences that were just too fleeting, intimate, or all-encompassing to have been caught on 35mm film. The following films illustrate the range of innovation in the area, and the way in which DV is being used to illuminate the poetry of existence and truth in the everyday.

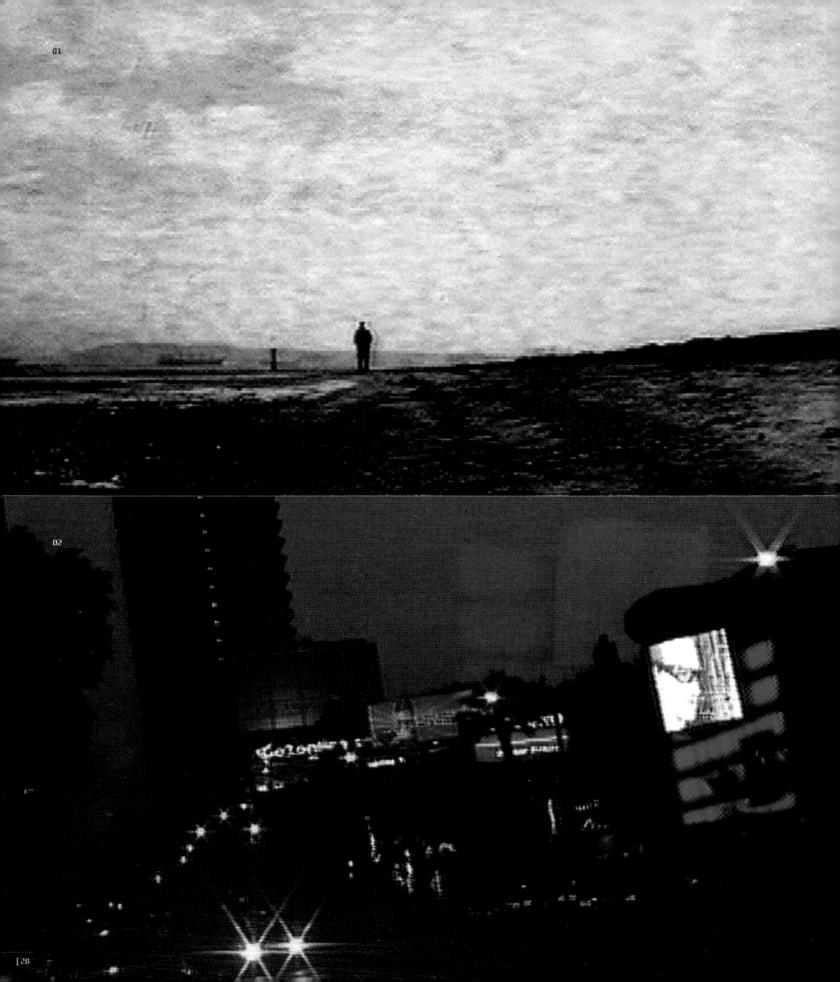

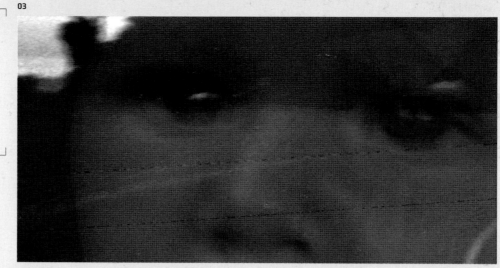

**FILM: NO MAPS FOR
THESE TERRITORIES
DIRECTOR: MARK NEALE
YEAR: 2000**

"I drove 12,376 miles around America and Canada in the course of production. William Gibson smoked over 900 cigarettes on our travels." Passive-smoking his way across North America, director Mark Neale auto-created a documentary-travelog on seminal sci-fi writer William Gibson, collecting over 50 hours of footage of the celebrated writer musing on the contemporary and fictional.

No Maps for these Territories (2000) is a documentary that arguably could not and would not have been made without the advent of digital technology. It subverts the idea of the documentary as something that is thoroughly objective, straightforwardly revealing reality, by incorporating digital effects whereby, for example, the scenery out of a car window rewinds, fast-forwards, and gives us an imagined moving vista— a landscape that is on the edge of the millennium. This grew from the documentarist's own circumstances. "It came from my own personal disorientation, basically, because I'd just moved out to LA from the UK about four years ago,"[i] explains Neale. "I was definitely in a suitable frame of mind to make a film like this—disorientated."

Cast adrift in this car culture, with a subject who reveals the flux of modern society, the way technology and industry mediates the way we live, it makes sense to center the subject in an environment that is sympathetic to the messages of the film. This break from the notion of a "butterfly pinned to a board"— objective and distant—reveals another strength of DV; a transparency whereby the subject reveals more than they necessarily plan. This micro-intimacy is made possible through micro-cameras, and the hidden nature of the filming process.

"I actually had different scenarios that I pitched [to Gibson] as ways to frame him and tell his story, and none of them quite worked for him. I wound up sitting in my car—'cause that's my car that it was all shot in—and I started thinking, 'Well, with not very much money, I could put cameras in this car. Maybe he would just be okay with that... Maybe I could drive him around and just see if that works.' And that's how it started. It was just empirical. I put a couple of little cameras in the car and drove him around LA for a couple of days in between other meetings that he was doing. I set my cameras up so that I would be able to put other things in the windows. I knew that I was going to play around with it in post-production."

In this way, Neale was able to take away the filming process and record a character surreptitiously, even if that character was complicit in the charade. This ability to witness and catch the unfilmable instils a truthfulness that is particularly evident in films also utilizing DV and as diverse as *Buena Vista Social Club* (Wim Wenders, 1999) and *Modulations* (Iara Lee, 1998). Both these films detail subcultures that have been previously overlooked by contemporary filmmakers. The former details traditional Cuban musicians, and so productively captures the charisma of these artists that a number of them subsequently became worldwide stars. *Buena Vista Social Club* infiltrated the controlled culture of the country through the "unofficial" nature of the recording.

Modulations successfully evokes the more communal nature of dance music and electronica, and of a culture that has a global resonance. The documentary is only able to do this through "remote filming", with crews thousands of miles away from the director, who wields ultimate control through consolidating and choosing the eventual way the rushes are edited. This ability to trace both the most global and local subjects into a picture of humanity's many facets is a fascinating by-product of the DV camera's democratization of image. Everything, however marginally experienced, has value —it can teach us something.

>>>

IMAGES

]01-03 [*No Maps for These Territories: road movie as digitized terrain, in a poetry of pixelation*

FILM: BODYSONG
DIRECTOR: SIMON PUMMELL
YEAR: 2003

The fact that we are able to come into contact with ever-increasing quantities of unmediated imagery is utilized to astounding effect in Simon Pummell's *Bodysong* (2003). Using a multitude of sources from "100 years of cinema" from around the world, Pummell weaves together found footage to create the story of an archetypal human life: a master recording of the experience, phasing between birth, growth, sex, violence, death, and dreams. He creates a mythic document that is a celebration, and also indictment, of the human spirit, by showing us the beginning of life and the end of it. Pummell is only able to do this through the richness of the material and the intimacies recorded through the enveloping presence of digital recording technologies.

"Our search included many unconventional sources; hospitals, research centers, individuals, sometimes just stuff people had tucked away in their attics," Pummell explains. "The film team produced a massive flow of possible footage. At one point, we were running three cutting rooms simultaneously to be able to sort and select from this mass of material. The image overload was sort of exciting and nauseating at the same time— the richness of it and yet the randomness of it. All the time we were looking for the patterns, the hidden signs, the connection with the story." The achievement for the director was to edit this overload of imagery into a coherent mass that essentially has a spiritual message rather than simply recording fact.
>>>

IMAGES

] 01 & OVERLEAF [*Bodysong: confluence of global and local, micro and macro imagery*

> "At one point, we were running three cutting rooms simultaneously to be able to sort and select from this mass of material"
>
> SIMON PUMMELL

FILM: MEETING PEOPLE IS EASY
DIRECTOR: GRANT GEE
YEAR: 1999

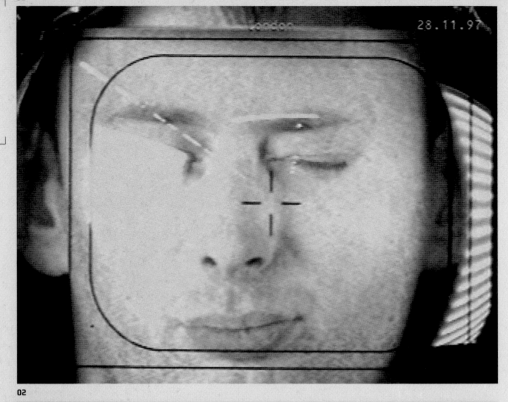

The ability to edit down essential moments into sharp relief is exemplified by Grant Gee's *Meeting People is Easy* (1999), the ironically titled documentary on the group Radiohead. The music documentary genre has been a fantastic beneficiary of the portability and convenience of digital filmmaking, but Gee uses digital technology not only to create a concert film, and explore the pressures of being a band on the road, but also to meditate on the nature of celebrity itself. His primary weapons were time and ubiquity.

Gee details his method: "When you're filming fly-on-the-wall style with DV cameras you're generally not so much of a pain in the ass, and people don't bother you or take you seriously. You're less visible, which, for me, is a positive. This allows you to shoot in situations without having to deal with location permits. Taking pictures on the street or on the subway, for instance. Put up a digibeta camera and tripod and within three minutes, somebody'll come and ask you, 'What are you doing?', 'Where's your permission?', and, 'Sorry, mate, you can't do that here.' If you just look like some tourist or home-movie anorak, nobody bothers you."

Without people bothering him, Gee is free to make sure the camera is always there. The film cuts seamlessly between concerts, from the first to the eighty-first. It is left running in the dressing room, reflecting a band disintegrating through boredom—through repeating the same song over and over in different continents and cities where the venues all look the same—an unwavering gaze, staring at the dressing room mirror. Saturating the image with acidic colors, as if to punch home the whole artificiality of the rock star life, *Meeting People* studies its subjects to coolly portray the power structure of stardom.
>>>

02

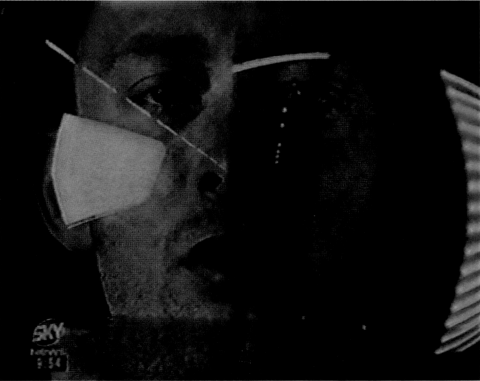

IMAGES

]01-02 [*Meeting People is Easy: captures Radiohead's videos*]03[*and concert tour in progress—a transition driven by success and celebrity*
] SEQUENCE OVERLEAF [*super-saturated imagery of anomie, urban alienation, and modern celebrity life on the road*

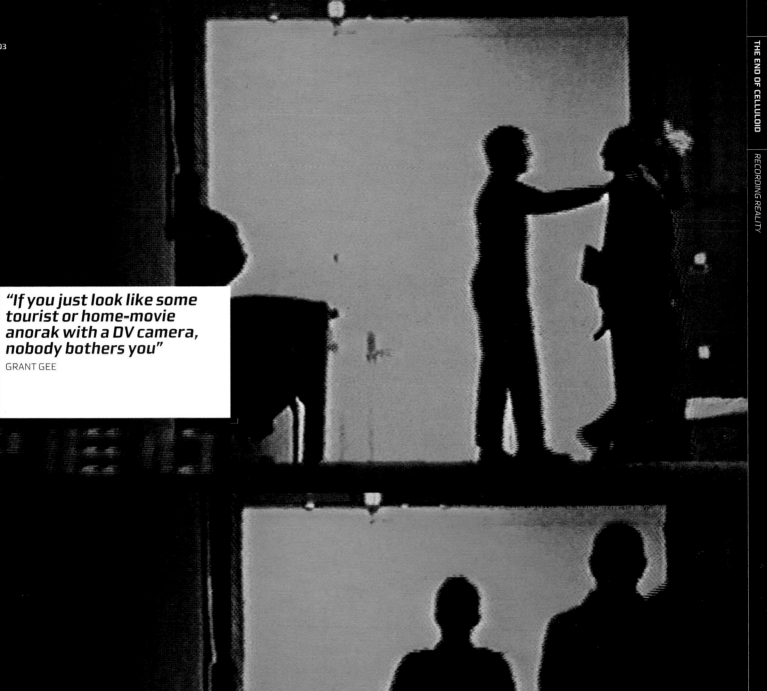

> **"If you just look like some tourist or home-movie anorak with a DV camera, nobody bothers you"**
>
> GRANT GEE

cure for cancer it's
Messiahs ... but

BABBLE

ANSWER: I think erm, [undergroud]
 and roll.

The last ten, fifteen

and then Tom cam

album, the finished

ANSWER: How would you define

ANSWER: A euphemism for sex

It's 1997. You're an
unassuming rock band from a
university town in the middle of
England. You make a record,
your third, that you quite like.
When it's finished, you release
it. No big deal – that's what
bands do.
The next morning, you wake up to

Better
(choose
than th
 So, F
whole
album
a point
stupidi
 On t

ANSWER: ... Saturday night, whe
 you're ready to drive t
 shake, that's [

ANSWER: finished by mid

QUESTION: How did you find [rock].

R: Time to get our
ANSWER: I think erm, [underground]
 and roll.

R: Yeah, get crack
ANSWER: How would you define ro

ANSWER: A euphemism for sex I be

ON: EMI seems pret

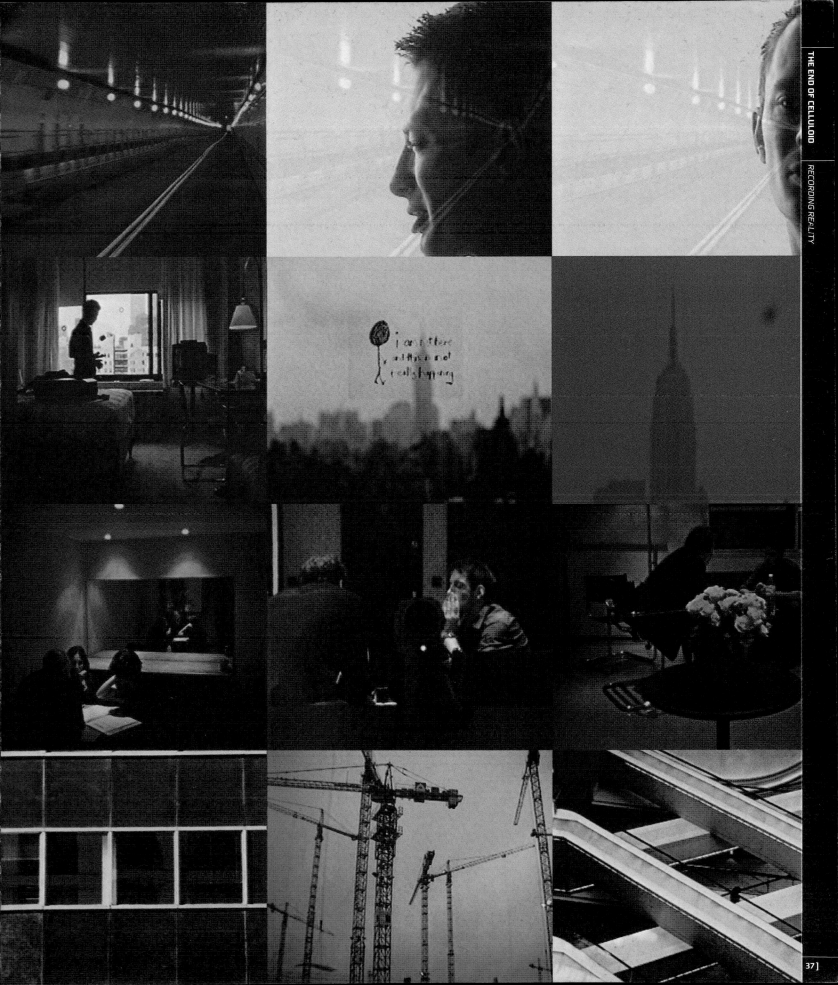

FILMS: A HOUSE WITH BROKEN WINDOWS, 400 ANARCHISTS
DIRECTOR: GRANT GEE
YEAR: 2002-

"I'm fascinated by the way that what we used to mean by 'image'—something on a flat surface, separate from us—is being replaced by a notion of images much more as a 'media'—material that we're in, like fish are in water, and which we're also constituted by," says Gee. "The various digital techniques seem to be early steps towards making a kind of total media possible and developing the aesthetics of total media. The fact that now everyone can be a filmmaker leads to a kind of image-inflation and subsequent devaluation. As with everything, it's both good and bad. I'm fascinated by this sense of us being on the cusp of a transition in our way of seeing. The way we image and are imaged-by the world.

"I am trying to describe the way it's happening, and its history. I've been developing a film about the early phase of the Mass Observation movement of the 1930s which was a kind of weird prefiguring of the new image-world."

Gee's documentary on this movement, *A House With Broken Windows* (ongoing), builds on previous work such as *400 Anarchists* (exploring the birth of identification and surveillance), to construct and layer ideas in an on-screen image space.

It seems to me that these documentaries feel so accomplished and so revealing precisely because the technology allows filmmakers to get closer to their subjects without intruding or imposing themselves on their surroundings. They don't disturb the equilibrium of the environment as a traditional documentary crew would. Yes, the miniaturization of cameras and filming technology allows them to do this, but so does the more pervasive sense of transparency that DV fosters. By removing the limitations of filming, the footage that can be taken is more direct. By taking themselves out of the equation, the filmmakers can play more freely with the form later on in the process. It's a process that, as it becomes more personal, also becomes more universal, creating, in effect, a ghost image that is imbued with emotion; an "anti-documentary".

04

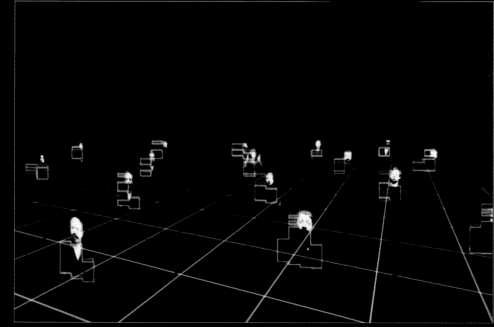

05

IMAGES

]01-02[*A House With Broken Windows: digital video gives Gee an opportunity to explore more oblique interests than those generally permitted by TV commissions*
]03-05[*400 Anarchists: the historical beginnings of the anarchist movement is explored in this art commission*

THE NEXT LEVEL
COMPUTER GAME-INFLUENCED REALITIES IN FILM

Screen entertainment has most often been about escape; about losing oneself in a story. But we know that the established order of entertainment is in flux when the most striking of recent science fiction movies—a genre that purports to be about the future but more often is actually about the contemporary world— concern themselves with virtual realities that bleed over into scenarios that have more in common, whether explicitly or implicitly, with computer-gaming worlds.

01

02

FILM: AVALON
DIRECTOR: MAMORU OSHII
YEAR: 2002

The Wachowski Brothers established themselves at the forefront of the science fiction movie genre by directing *The Matrix* trilogy. The films, about a band of computer hackers who escape a virtual world created by machines to subdue the human race, and begin to fight back, are a blend of styles and storylines tailor-made for a global audience. The films are complemented by the video game *Enter the Matrix* (2002), and a series of anime shorts, collected under the title *Animatrix* (2002): both of these releases expand the plotline, offering new dimensions and information on *The Matrix* world.

Director Mamoru Oshii is revered in his native Japan for his work on animated films *Mobile Police Patlabor 1* and *2* (1989 and 1990), *Ghost in the Shell* (1998), and, most recently, the live action/animation hybrid, *Avalon* (2002). *Avalon* explores a scenario in which the heroine, Ash, plays a virtual video game for a living, and who, on learning of a hidden level in the game, decides to beat the code that traps her in the system.

The cult appeal of all these films in today's entertainment-scape lies in their successful integration of ideas and concepts more commonly associated with computer-gaming worlds. These films, by absorbing contemporary entertainment styles, connect with an unfulfilled part of the collective modern psyche. It also shows that computer gaming is entering the mainstream, its aesthetics and forms bleeding into the visual vocabulary of the general population.

Like most new forms of media, computer gaming is still demonized in some quarters. Its legitimacy as an art form is questioned, primarily due to its lack of linear narrative. So what happens when feature films start incorporating these fractured narratives and kinetic gaming styles? It's time to move to the next level of cinema—one that incorporates a more fluid and sophisticated sense of synergy between what is imagined and what is real.

Oshii expounds on this point: "Hollywood films about virtual reality always end with a return to the real world. However, because those real worlds exist inside film, they themselves are lies. Reality is a questionable thing. I didn't want to do a movie where the characters returned to reality. The reality we experience is an illusion inside the heart of each individual."

These films are highly literate, employing visual techniques rather than elaborate scripting to elucidate on the story. It is appropriate that they enlist the aesthetic and narrative trappings of video gaming, a medium that could not exist without digital codes, to investigate our own codes of existence. When Ash defeats an enemy inside Avalon's battle simulation mid-explosion, they freeze in 2D, and the layers fracture and then dissolve. This reminds us that each layer is programmed: whether DNA or binary zeroes and ones, we all exist as code, reproducible.

This idea refers to the work of French philosopher Jean Baudrillard, who argues that in the modern world there is a redundancy in difference between what is a copy and what is original [i]. Digital copies are indistinguishable from their originals, so what is the value in the original form?
>>>

IMAGES

]01-03 [*Avalon: each scenario revels in its illusory nature, blurring the boundaries between gaming and reality*

142858
01898
00478

Main Battle Tank -1
T -72M2
57-412-9174

176598
01789
01898

Main Battle Tank -1
T -72M2
57-412-9185

200337
01958
00868

088333
-00082
-00765

A-025361 Wasteland
125898 013808 088808
-0032 0346 0192

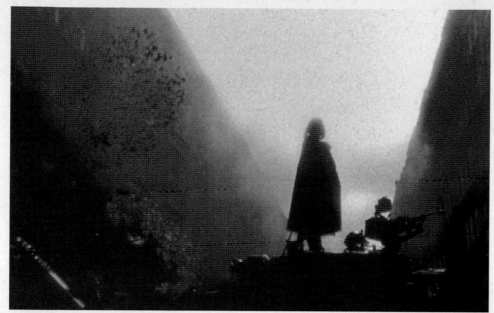

These films inspire such contemplation because they are exegetic; they offer playful explanations of the way things are, could, or should be. They captivate because, rather than offering a hermetic alternative or fantasy reality outside our parameters of existence, they offer an explanatory layer to the real world. They reveal the dissolving interface between fiction and fact, and imbue it with deeper meaning.

Oshii concurs that: "What we perceive as reality depends on ourselves. If you live in a world where you repeat the same action every day, you may indeed be in a very empty and meaningless reality... one of the aspects I wanted to depict with the images [where statues have no faces, and books are filled with empty pages]. When Ash enters the game, she makes a deal: there are rules and there is a concept. In that sense, the necessity for books and faces on statues disappears. A lot of meaning, information, and data get lost that way if you focus only on the deal of the game and the repeated action that you have to perform. For me personally, Ash's imaginary world is not really any different from what I conceive as my real world. I don't make any clear distinction."
▷ ▷ ▷

This philosophy is key to *The Matrix*, where the machines have recreated human civilization through complex artificial intelligence routines and physics models (think of a "Real World" gaming engine). Neo, the lead protagonist, even has a copy of Baudrillard's book, *Simulacra and Simulation* (1981), a convenient handbook and signpost to what to expect as the trilogy unfolds. This idea of a simulated universe, replete with a comprehensive back story, is supported by the website [ii], which has a section devoted to the philosophies that sustain the movie.

While it is revealed in *The Matrix Reloaded* (2002) that this Matrix is being played out, copied with minor variations *ad infinitum*, with cruel disregard for the meaningfulness of everyday existence, *Avalon* is subtler and has a more subversive message. Ash's search for the authentic is foreshadowed by her everyday existence. In her journeys through the bleak urban sprawl of a baroque Polish city, she passes beheaded statues and people standing still, like ciphers—inanimate sprites yet to be activated by any kind of desire. By clearing "Special A," a secret level of the game simulator (a device that neatly echoes the popular habit in computer games and software to hide "Easter eggs"—hidden special features uncovered only by special maneuvers), Ash enters "Class Real." This has the appearance of a modern-day Polish city and, whether virtual or not, it is a reality that Ash can accept.

IMAGES

]01-03[*Avalon: a hyperreal representation of a game world as reality, with complementary graphic codes*

FILMS: THE MATRIX TRILOGY
VIDEO GAME: ENTER THE MATRIX
ANIME SHORTS: ANIMATRIX
DIRECTOR: THE WACHOWSKI
BROTHERS
YEARS: 1999-2003

These films' investigations into the nature of reality become increasingly relevant as the seduction of virtual environments becomes progressively stronger. Greater computing power has become ever more successful at creating these simulations. The appeal of these environments is that they are milieus constructed upon set rules; they don't subscribe to the world's natural state of entropy, one that is essentially chaotic and random. Ever felt the need to hit the reset button?

Elemental to this next level of filmmaking is the need for it to create alternative mythologies. Overtly allegorical Bishops and Archbishops lead *Avalon*'s gaming parties, acting as overlords of this simulated world. It is a theme that Oshii has explored in animated form in the cult feature, *Ghost in the Shell*. In this anime feature film, Kusanagi, the main character, is a cyborg, exploring what it means to be a ghost in the machine—a soul trapped in a synthetic body—in an attempt to reconcile the spiritual and technological.

The idea of resurrection and the creation myth, intrinsic to religion, is also central in *The Matrix*. It applies the game-playing model of the ability to collect a number of finite but extensible lives, and characters that are in fact artificial constructs, possibly doomed to repeat the same actions and mistakes. But, eventually, *The Matrix*, *Avalon*, and *Ghost in the Shell* all lead to transcendent action moving beyond the strictures of physical reality. As religion becomes increasingly marginalized, even obsolete in a rational society based on science and technology, the need for myths and exploration of the spiritual becomes more important. These myths need to be all-encompassing, giving rise to a phenomenon I categorize as "screen bleed."

IMAGES

] 01-05, 07-11 [*Enter the Matrix: footage from the film is mirrored in game environments and scenarios, offering a deeper potential for player engagement and satisfaction in an extended fictive world*
] 06 [*The Matrix Reloaded: flaunts the normal constraints of traditional media*

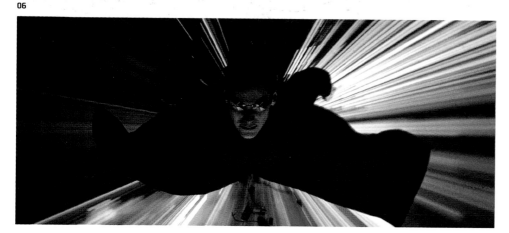

Originally a technical term (when non-broadcast safe colors, which are very bright or color-saturated, bleed into other areas of the screen), screen bleed is a useful term to appropriate to describe a modern narrative condition where fictive worlds extend into multiple media and moving image formats. I believe the condition of screen bleed is proliferating due to the immersive 3D worlds we explore as game players and digital media consumers. This is why all-encompassing mythologies are the most resonant with contemporary audiences. After all, if a gaming experience is so involving, so *cinematic*, why shouldn't we expand the experience into film or interactive online worlds, where each strand of narrative offers a new dimensional layer?

This need for an extensible *mise en scène* can be seen in the way the most complete, distinct narrative worlds—*Lord of the Rings, Star Wars, The Matrix*—propagate in different media. Sci-fi and fantasy worlds represent the best way to do this, as they construct environments and objects that are immediately transferable across media, being so foreign and distinguishable from normality. *The Matrix* is probably the most high-profile use of screen bleed yet seen in contemporary media. It utilizes an interconnecting series of capsule narratives that are anchored by the trilogy. The fact that *Matrix Reloaded* and *Revolutions*, footage for the *Enter the Matrix* game, and the anime short film collection *Animatrix* (which fills in additional back story), were produced concurrently, makes it a unique undertaking so far in entertainment history. Each part of this world works as a discrete unit, but adding the stories together completes the narrative.

>>>

Allusions or references to events or characters that appear in one form and not another, rather than making the active entertainment feel incomplete, add to a believable and convincing narrative world in motion. After all, how many of us understand totally what is happening around us? We are never absolutely informed. The increasing depth of understanding we do get is crucial to our progressively greater pleasure in experiencing the universe. A planned *Matrix* online universe where you can continue this experience with like-minded individuals through a MMOG (Massively Multiplayer Online Game) can only disappoint if it doesn't adequately simulate the universe already set up.

So, while video game auteurs often look to feature films for inspiration (no doubt because these are still larger-scale enterprises with larger budgets, production staff, and art departments to develop a sophisticated look and feel), films increasingly adopt the GUIs (Graphic User Interfaces), graphic codes, and freeform camerawork of games.

When Ash makes a spectacular helicopter kill in *Avalon*, earning her virtual reality level completion, the situation deliberately apes the gaming convention of the level-ending confrontation with the "Big Boss" (often a technologically enhanced foe). In the sky above the frozen, exploding wreckage floats a shiny, revolving "Mission complete," her game stats prominently displayed as she jacks out of the simulation.

>>>

IMAGES

]01-09[*Enter the Matrix: the game allows greater interaction for the Matrix fan, revealing character discoveries separate from the narrative of the movie.*
]10[*The Matrix Reloaded: strong characters encourage "screen bleed" between media*
]OVERLEAF[*Enter the Matrix: the Agent Smith avatar faithfully recreates the movie character*

[48

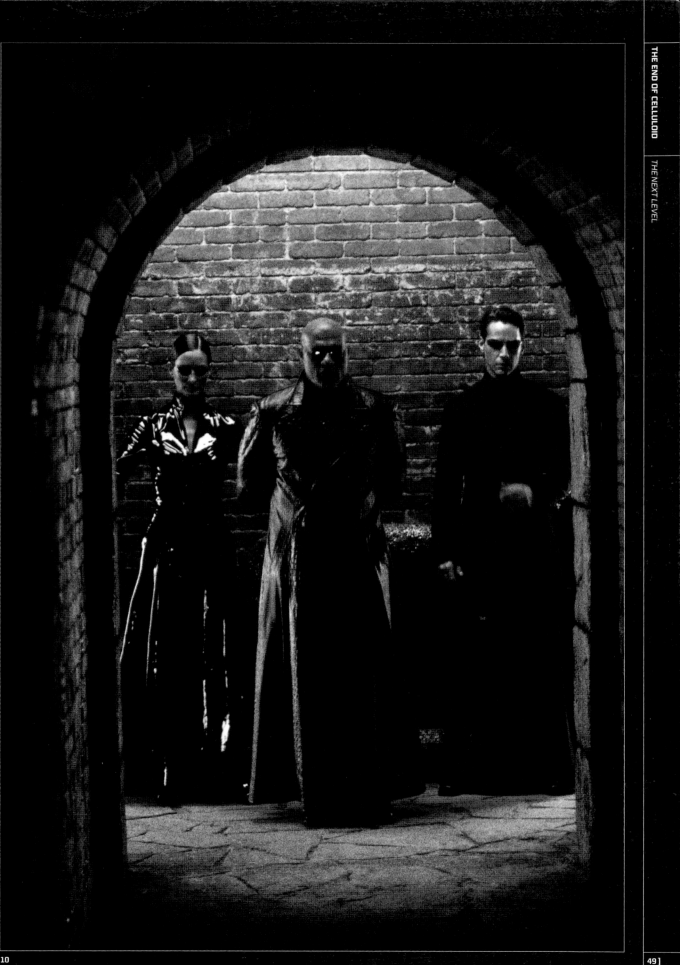

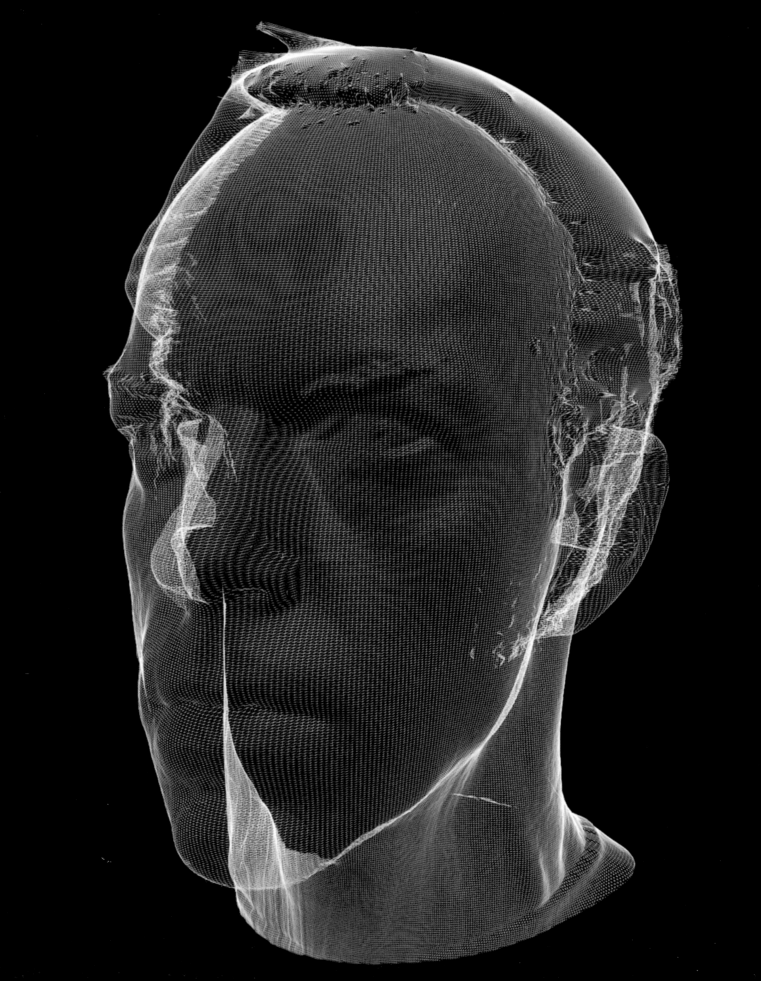

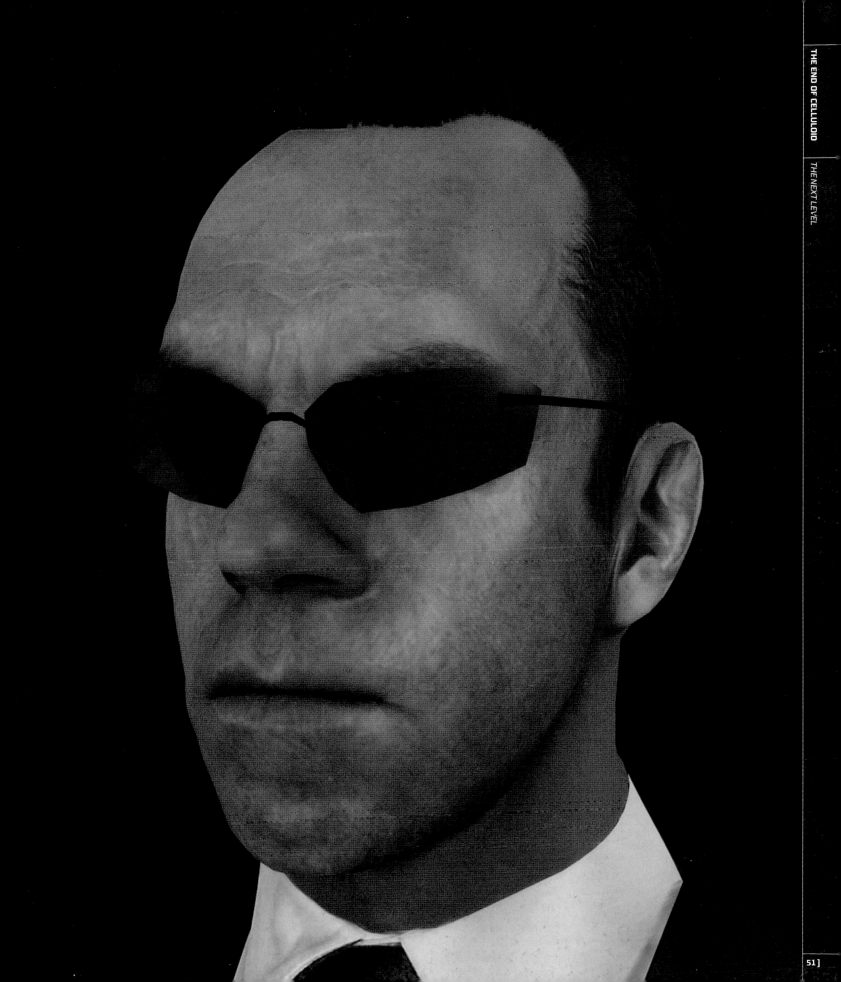

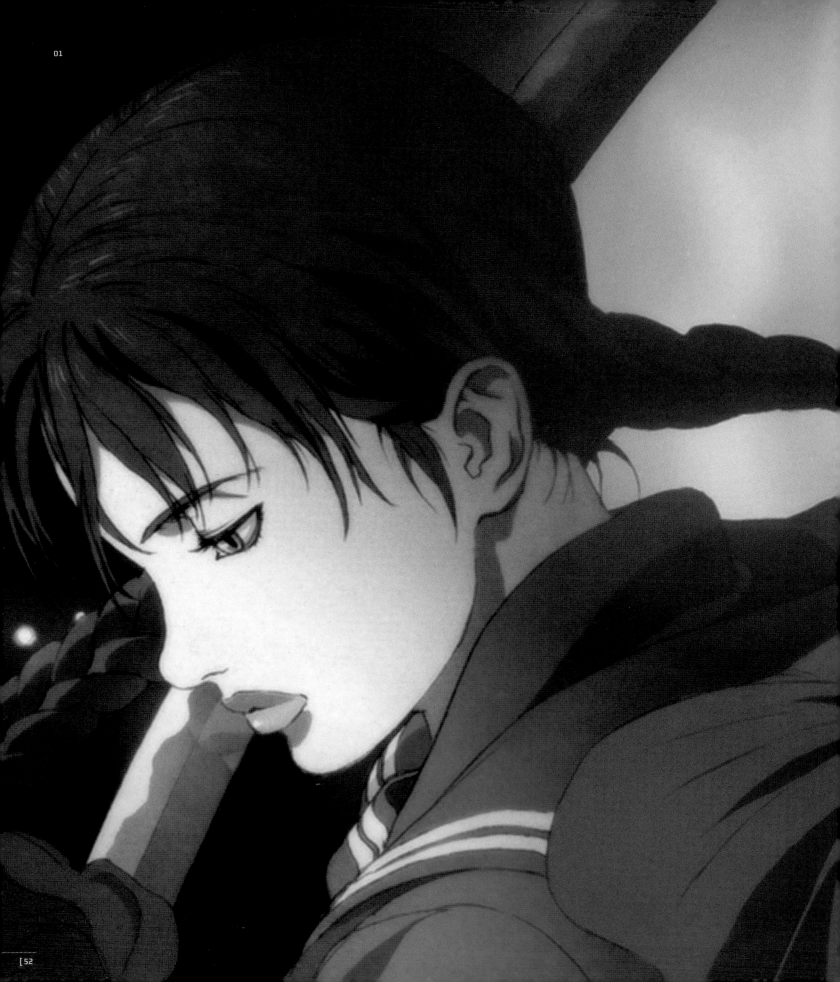

**FILM: BLOOD—THE LAST VAMPIRE
DIRECTOR: HIROYUKI KITAKUBA
YEAR: 2000**

Avalon also displays a classic Japanese narrative pattern of *ki-show-ten-ketsi*, which reflects initiation, interpretation, deviation, and termination—a form that is more commonly familiar in the West in computer games, not surprising considering Japan's continuing domination of the medium.

While the game-playing analogy is inherent in *Avalon*, in the contemporary digital animation feature *Blood: the Last Vampire* (2000) games don't feature at all. This is an animated action film in which a young Japanese girl must slay lycanthropes that have infiltrated a military base—a period *Buffy the Vampire Slayer* with film noir leanings. While a *tour de force* of animation and mood, what is most fascinating about the film is the fact that, whether director Hiroyuki Kitakuba intended it or not, it feels like a game. There is little exposition on the situation, and the young girl is thrown into a combat scenario that imitates the setting of a game level. Moreover, the way in which the action tracks between settings, and the spatial composition, are more reminiscent of something like the *Resident Evil* series of video games. It ends abruptly, a "Big Boss" being spectacularly defeated. Level complete. No room for emotional growth. The purity of this object-oriented narrative harmonizes with the watchers' love of momentum, of *doing* by *being* the character, and ultimately of simply enjoying the spectacle.

Contemporary entertainment maps and plays out the continuing struggle we face in reconciling originals and copies, fact and fiction, reality and illusion. Computer gaming reduces this down to a microcosm, making the metaphor explicit and more immediate. The next level of entertainment is engaged in mythopeia—the creating of myths—to reconcile these issues, to abstract them down to essences. To continue to do so will entail further assimilation of digital art forms into the traditional for them to continue to be vital artistic expressions. "Our identity should allow us to create and decide for ourselves what we perceive as reality," says Oshii. Entertainment must adapt to help us realize this need.

IMAGES

]01-02 [*Blood—The Last Vampire: protagonist as computer game character and killing machine*

SOURCES

[i] *Symbolic Exchange and Death,*
Jean Baudrillard, 1976
[ii] *http://whatisthematrix.warnerbros.com*

PLAYER VS. SPECTATOR
GAME AS CINEMA, FMV, CINEMATICS, AND MACHINIMA

We've traveled thousands of miles down pixelated tracks, fired millions of rounds into polygon foes, and jumped into the infinities of virtual space to be brought to this point. Millions get lost in game worlds that cinema can rarely come close to replicating.

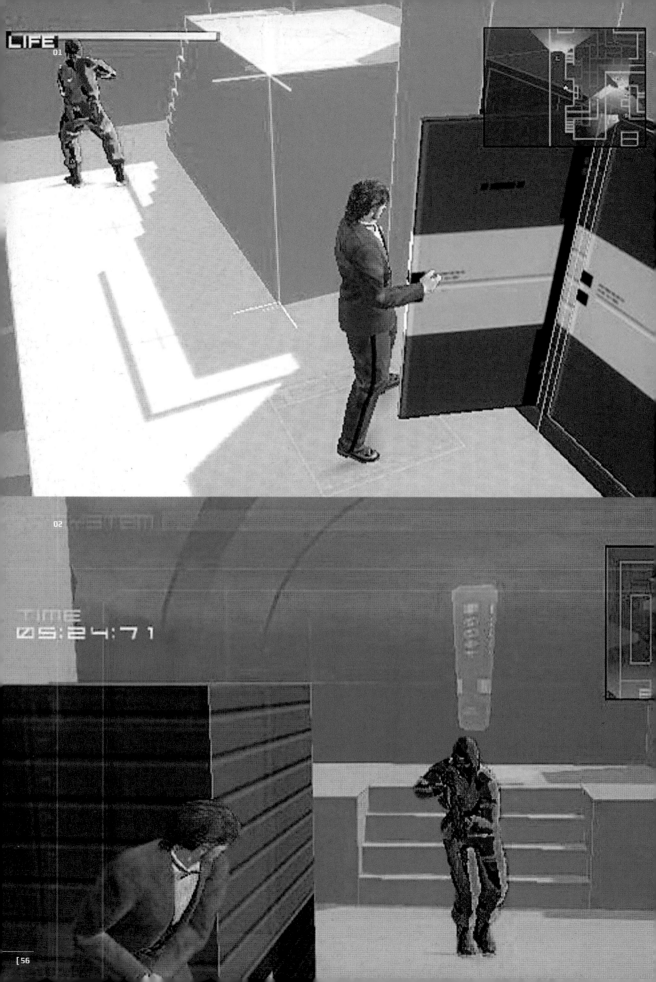

> **The narrative rules of cinema can be transferred into a real-time animated environment, and then followed as a basis to build drama within a game**

Who would have thought that the jerky, two-dimensional sprites of 1980s icons Pac Man and Super Mario would eventually morph into the sophisticated three-dimensional 1990s icons, such as Solid Snake, Lara Croft, and Link? These are the superstars of the computer-gaming firmament. Like their A-list Hollywood equivalents, such as Tom Cruise or Cameron Diaz, they are almost certainly guaranteed to "open" a game, with a fan-base that is guaranteed to pre-order the latest instalment of their franchise. This development of the lead characters of the *Tomb Raider, Metal Gear Solid,* and *Legend of Zelda* series of computer games into emotive and involving virtual actors was the last hurdle in transferring a total cinematic experience into a virtual world. The fact that we have the power to manipulate and explore a virtual environment as our favorite character in an imagined world makes gaming a highly compelling media experience. It neatly illustrates the general trend that every new entertainment experience developed is somehow more immersive than the next.

The creation of an entertainment medium that is not confined to the screen, and that encompasses more than the visual, has been a common theme of concern that is neatly explored by Janet H. Murray in *Hamlet on the Holodeck* [1]. In this text, she cites the "televisor parlor chambers" of Ray Bradbury's *Fahrenheit 451* (1953) and the "Feelies" of Aldous Huxley's *Brave New World* (1932) as literary precursors of digitally immersive entertainment. At the moment, the most plausible and "authentically" cinematic gaming worlds are those that offer an "on-rails" experience. They are manipulable within certain confines, in which we can control a character between places, but are ultimately guided through a game-world to trigger events that set off the next step in the story. These events are not necessarily linear in nature; a number of independent or intertwined story strands—capsule narratives—may run at once. The actions of the character can affect the way these capsule narratives develop. The way they are set up shows that the narrative rules of cinema can be transferred into a real-time animated environment, and then followed as a basis to build drama within a game.
>>>

IMAGES

] 01-02 [*Metal Gear Solid—Substance: creates a compelling cinematic narrative*
] 03-04 [*Metal Gear Solid 3—Snake Eater: moves Solid Snake into jungle territory*

The computer-gaming visual aesthetic is increasingly filtering through to other visual media

Machinima distinguishes itself by being animation based on real-time visual engines, but until recently the computer power just wasn't able to do this. Full motion video (FMV), pre-rendered then played back during intro and cut scenes of a game, has historically been used to drive the cinematic element in games, for plot exposition, and to flesh out character behavior.

I became fascinated by the way these CG worlds were twisting cinematic effects to their own ends while researching *Lens Flare* [6], a pioneering annual cinema program created to showcase the most visually stunning and progressive computer-gaming cinematics. Much of their fascination lies in the way in which they distill film language, borrowing and mutating freely from the scenarios of popular feature films to create dramatic miniature interludes. As the form has advanced, these interludes have become longer and more technically and emotionally complex, such as in Sega's *Shenmue* (1999), Capcom's *Onimusha* (2001), or the *Final Fantasy* series by Squaresoft. Indeed, *Final Fantasy* was so successful as a series that it garnered its own high-budget feature film— *Final Fantasy: The Spirits Within* (2001). >>>

IMAGE

]01-06[*Rebel Vs. Thug: by using machinima techniques, action can be filmed as a fluid and immeasurably modifiable mise en scène*

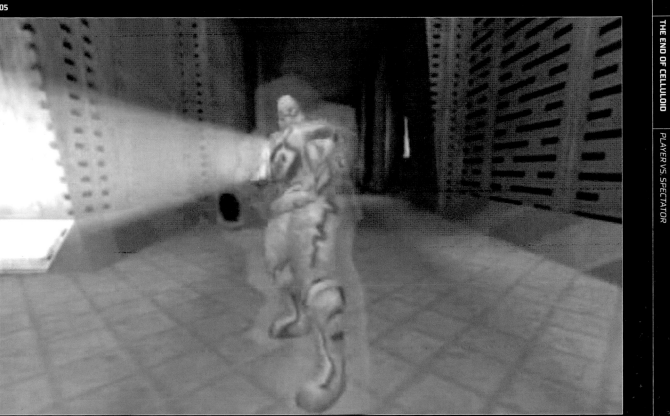

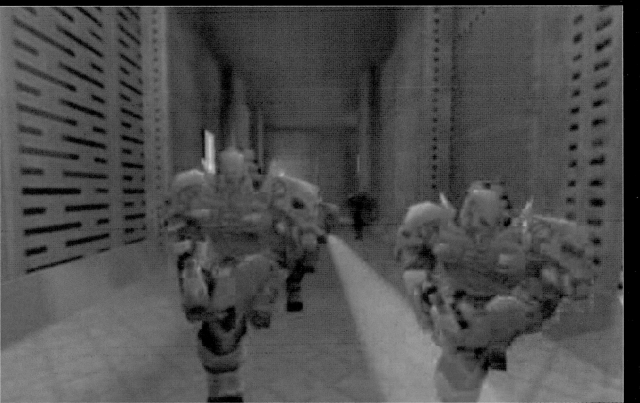

01

> *"Perception and understanding have come to a stop, and spirit moves where it wants"*
> CHUANG TZU, ANCIENT TAOIST SCHOLAR

02

04

FILMS: ESCHATON, STEELWIGHT
DIRECTOR: STRANGE COMPANY
YEARS: 2002-2003

While the very best FMV is miles away from homebrew machinima, we can expect a flowering of the form similar to the range we get between Hollywood and independent cinema. The increasing power of these gaming engines as animation tools, and their flexibility as gaming tools, indicates that we'll continue to see a new generation of directors influencing cinema through an appreciation of computer game-inflected action. Indeed, through programs such as *Lens Flare* and the mainstreaming of next-generation gaming consoles, such as PlayStation 2 and Xbox, the computer-gaming visual aesthetic is increasingly filtering through to other visual media.

We will also see many more viewers becoming "interactors," comfortable with exploring and influencing the plot and proceedings themselves. As it matures, computer gaming is taking over from cinema as the modern frontier of drama and dramatic action. And as it makes stars of alternative Snakes and Laras, we will see a future populated by these icons, unfettered from their gaming origins, moving freely between these most narratively compelling and immediate visual arts. We shall all become both players and spectators.

IMAGES

]01-02[*Steelwight: a new machinima series by Strange Company*
]03-04[*Eschaton: early machinima series based in the Cthulhu universe*

SOURCES

[i] *Hamlet on the Holodeck,: The Future of Narrative in Cyberspace, Janet H. Murray, (1998)*
[ii] *Hideo Kojima interview, www.IGN.com (12/2000)*
[iii] *Creativity: Flow and the Psychology of Discovery and Invention, Mihaly Czikszentmiyalhi (1996)*
[iv] *Hideo Kojima interview, www.IGN.com (12/2000)*
[v] *www.Machinima.com*
[vi] *Lens Flare, an annual onedotzero digital film festival program of the best computer gaming visuals, created by Matt Hanson and Shane Walter*

THE DARK CORNER
DIGITAL VISIONS ON THE MARGINS

Digital filmmaking enables the filmmaker to cast light into the dark corners of their minds, giving us a clearer look at their more personal visions. In these corners, waiting to be discovered, are ideas that just weren't possible or practical before the CCD (charge-coupled device) came along. And while a certain type of new filmmaker is moving toward an accelerated cinema— a new type of cinema integrally effected by digital technologies—others, particularly established directors, are using the opportunity that this new equipment gives them to reinvigorate their own work and move in unexpected directions. They are tackling subjects that are more relevant to DV production or animation, either because of intimacy, aesthetic, environment, or scale. For some directors, digital cinema's breaking down of technical barriers creates a sense of freedom, so they are able to concentrate on working with their actors. For others, the freedom lies in how they can play with images and ideas once the action has been "filmed".

FILM: TIMECODE
DIRECTOR: MIKE FIGGIS
YEAR: 2000

Mike Figgis, director of the Academy award-winning *Leaving Las Vegas* (1995) has become rapidly engaged with the digital medium—so much so that it appears to have usurped his previous way of operating.

Figgis admits as much: "I have absolutely no desire to go back to 35mm. It's too slow. It's not fun. It's a technical bog that you get stuck in, and either you like that bog and that makes you happy and excited or you don't. It doesn't work for me. It makes me bored and frustrated, and I get very angry. I think it gets in the way of storytelling. The aesthetic results that you get with 35mm are undercut by the absence of energy in the performances." [i]

Having seen the impact on his own work, Figgis is all too aware of the resistance within the industry to digital media, and the results this may have: "There must be a lot of resentment about the ease of this technology. Think of a guy who has worked in the industry for 40 years, learning the techniques of cinematography, and who sees a bunch of "school kids" shooting a movie like *The Blair Witch Project* (1999). I do sympathize with them, but the fact of the matter is that you can't turn back the clock—it's here and we have to welcome it into our film culture." [ii]

With a history of pushing at the borders of the celluloid frame, it seems inevitable that digital video would spark Figgis's imagination. So much so, in fact, that one frame was obviously not enough. *Timecode* (2000), his first major digital work, broke new ground in two ways: it is a drama shot in real time over 93 minutes, without any edits, and the screen is split into quadrants. This device allows the viewer four windows into a world of film industry intrigue, based around an LA-based production office. It is a novel utilization of what media theorist Lev Manovich has termed "spatial montage". [iii] An extension of the more usual split-screen, it is a technique contemporary audiences are familiar with from live feeds and picture-in-picture news footage accessible via digital television 24/7. Computer game players will be even more comfortable with this approach of roaming between frames to monitor the most pertinent action—anyone playing multiperson games, such as the classic Nintendo 64 game console's *Goldeneye* (1997) first-person shooter, is already familiar with this mode of seeing.

Figgis explains part of the reason culminating in *Timecode's* quadrangle format: "The real criminal in the corruption of cinema is editing and the system of telling lies through cutting, through interruption. Psychologically, it's a corruption. So this film is, in some ways, an attempt to show that we can edit in a different way, through montage rather than cutting, and we can have simultaneous action. This allows each individual to have a very different interpretation. There isn't one interpretation—that's not rich enough today." [iv]

This approach may be more challenging for both the filmmakers and the viewers, but its results are involving. It calls for more in-depth choreography and intensive rehearsal from actors to synchronize action. It makes for a more intense audience experience, where the viewers—by choosing which frame to concentrate on—effectively edit the action by themselves. The viewer controls the film they want to see, which borders on what Janet Murray has described as "agency" [v] —a sense of control over the story—a quality much more familiar in the realm of computer gaming.

Figgis cites Robert Altman and his 1975 movie *Nashville* as a huge influence on *Timecode*: "Had the techniques I've used been available to Altman, I feel that he would have used them". Altman, expert at juggling ensemble casts, and multithreading action, had to rely on giving one interpretation. By allowing viewers their own readings, Figgis is not delegating responsibility for the "final edit"; he is simply making it more transparent and nuanced. In any case, by directing the original action—what the camera sees—and guiding the viewer to the most appropriate action on-screen through emphasizing the appropriate audio channels, the director is still the ultimate creator of the experience.

Figgis has made a successful feature film that simultaneously presents multiple action sequences, which has an appeal beyond an "experimental" niche. He also offered different directorial interpretations of the movie through live mixes of the audio track on tour, like a music DJ. The DVD takes this one step further by turning the viewer into an "interactor," as they can switch between the audio for one of the four quadrants being presented on screen when they wish.

"We've evolved beyond an art cinema of static landscape shots," says Figgis. "I'm not just making an art piece about synchronicity, I'm still very interested in making stories, and I feel like the twelve years I've spent making films has served as an apprenticeship in a certain kind of narrative language and a style of storytelling. But at the same time, I want to do something that has a wider overview of an audience's ability to read more than one idea at the same time."
>>>

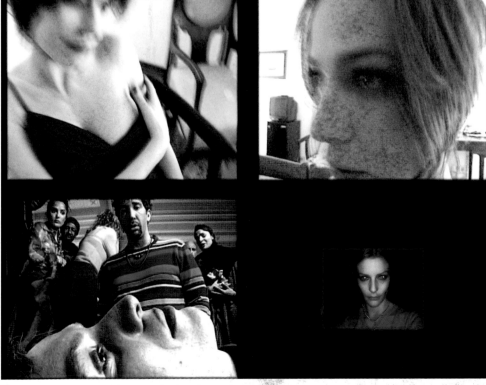

IMAGES

]01-02[*Timecode: four simultaneously aired, feature-length single takes required organizing multiple camera crews. The novel form of music sheets were used to coordinate locations, actors, and timings*
]03[*Hotel: Figgis further develops split-screen territory first explored in Timecode*

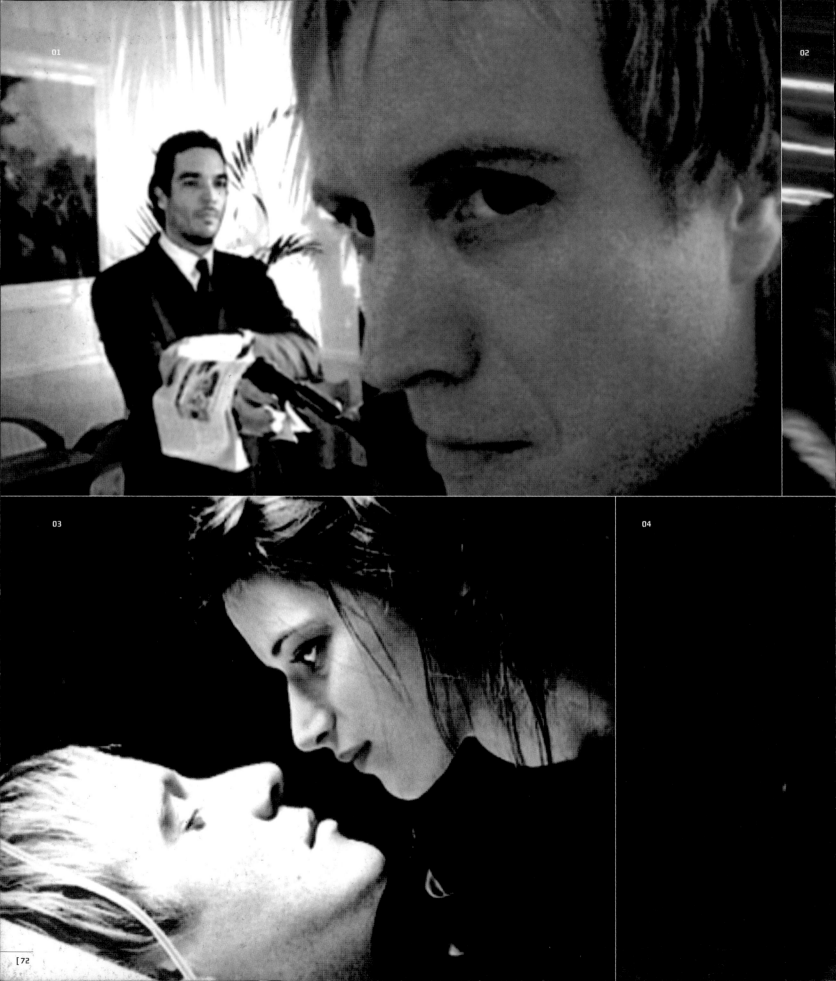

FILM: HOTEL
DIRECTOR: MIKE FIGGIS
YEAR: 2001

Figgis's prime motivation in using the new tools and techniques lies in the transparency of digital filmmaking, which allows him greater access and immediacy to his actors. Smaller crews, smaller cameras, and less lighting equipment all enable a less rigid approach for the crew and actors.

After *Timecode*, Figgis took a more extreme approach with these methods. *Hotel* (2001) follows a diverse cast of characters in a Venetian hotel while they re-enact a version of *The Duchess of Malfi*, a classic Jacobean play. The film explicitly explores in-depth improvization and experimental filming techniques, including in-camera filters as well as post-production split-screen effects, in controlled and uncontrolled settings—such as amongst the tourists in St. Mark's Square, Venice—without giving the director the "distraction" of a feature-length, continuous take to worry about.

"I've become more confident with my last couple of films and have been experimenting more with narrative. Audiences are restless and ready for alternative ways of telling stories. I have zero interest in special effects. Special effects are for me a waste of energy. I cannot imagine not wanting to work with actors or people," says Figgis.

>>>

IMAGES

] 01-04 [*Hotel: Figgis took the opportunity to use video in a freeform, experimental way, rejecting the usual rigidity of film cinematography*

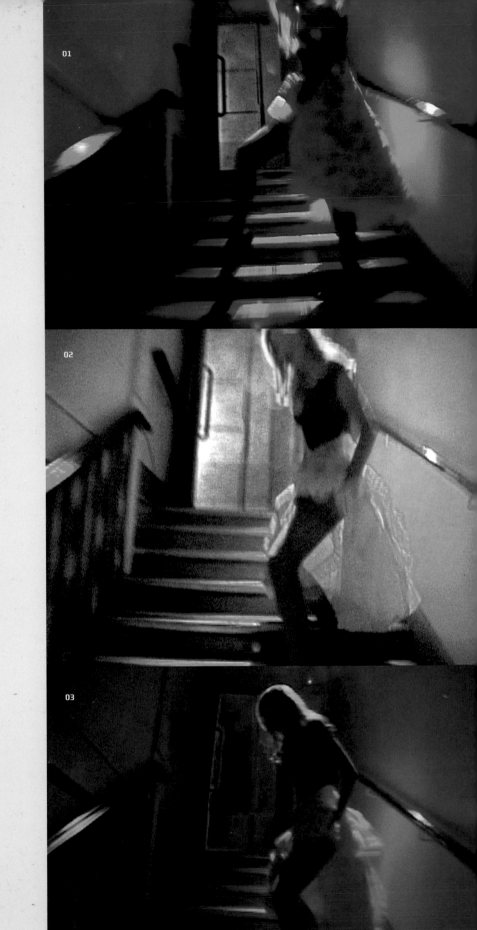

**PROJECT: 10 MINUTES OLDER—
THE CELLO
FILM: ABOUT TIME 2
DIRECTOR: MIKE FIGGIS
YEAR: 2002**

Hotel plays with *cinema vérité* (literally "film truth," a style of filmmaking developed by French film directors in the 1960s), colliding the period setting of Venice with the styling of fly-on-the-wall documentary. Digital filmmaking provides the space to fuse style and genre, as is the case in this feature film. *Hotel* uses the opportunity to melt genre territories, both fantasy- and reality-based (such as a vampiric sub-plot, alongside a celebrity TV format). Compared with *Timecode*, the more uncontrolled experimentation of *Hotel* is a more strange and unsettling experience for the viewer. Its progressive nature is almost guaranteed to divide audiences, but, as a film, it undeniably creates an original space for itself.

About Time 2 is Mike Figgis's contribution to the portmanteau film project *10 Minutes Older: The Cello*. This project was set up to explore the technology of film. A series of well-known directors—such as Jean-Luc Godard, Wim Wenders, Jim Jarmusch, and Werner Herzog—were involved, illustrating that filmmakers are more than willing to explore digital possibilities to provide viewers with alternative visual experiences.

Figgis is quite right when he says, "As an audience, we've been corrupted by too much sugar and too much popcorn."
>>>

IMAGES

] 01-05 [*About Time 2: super-saturated images and spatial montage using split screens are becoming Figgis motifs*

04

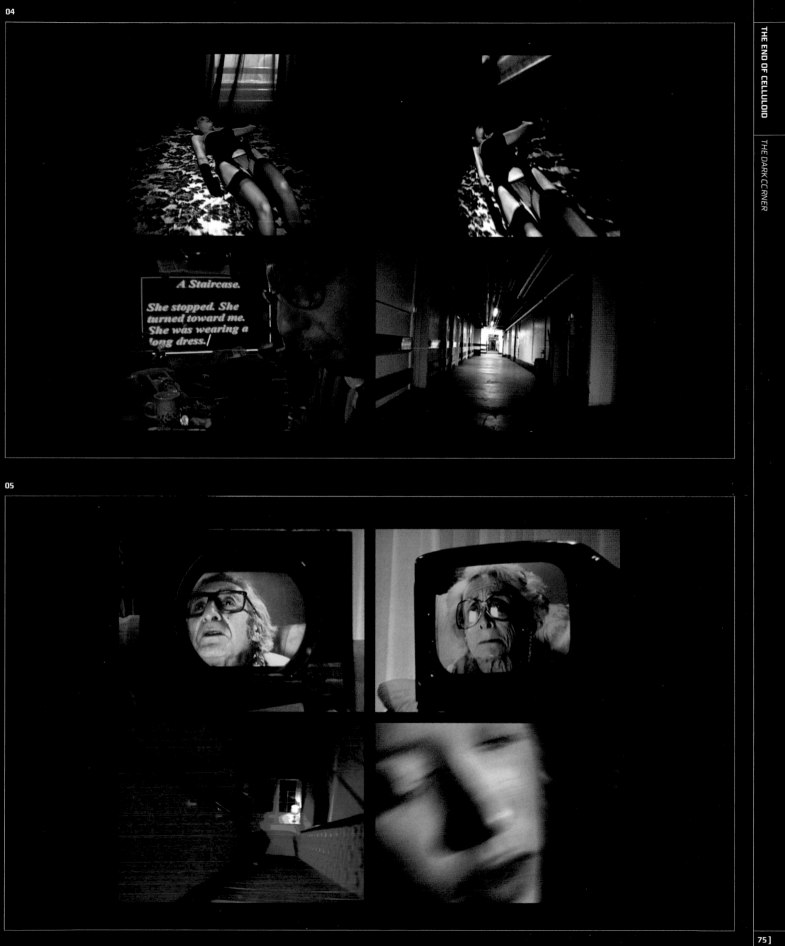

05

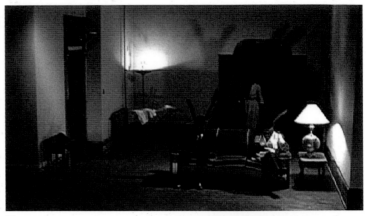

01

02

03

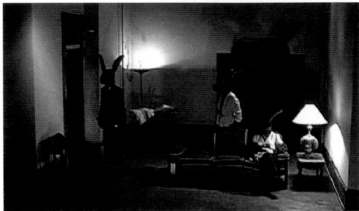

04

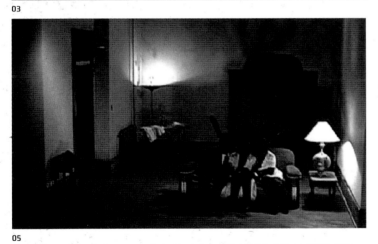

05

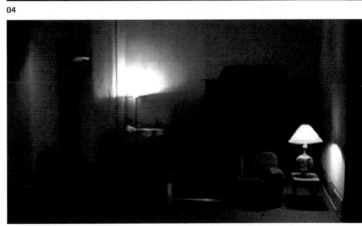

06

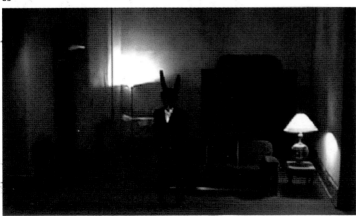

07

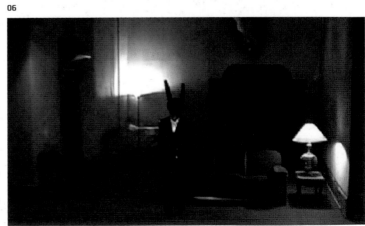

08

FILM: RABBITS
DIRECTOR: DAVID LYNCH
YEAR: 2002

"It doesn't really matter
what way you work, or what
medium you work in, it's all
about ideas. Sometimes
ideas want to be furniture
and sometimes they want to
be a story in film"
DAVID LYNCH

David Lynch is another filmmaker experimenting with the digital who deals in things that are altogether more corrupting for the viewer than the usual multiplex commodities. He is similarly using the digital format to fast-track his ideas, laying them down not only to digital video, but also specifically for the Internet. His website [vi] extends his already extreme vision into digressions of whimsy and artistic exploration that wouldn't necessarily lend themselves to the feature-film format [vii]. Free from the constraints of celluloid, and the accompanying timeframe, he has created a number of web-exclusive moving-image works.

"We've all got something that wants to get out. We've got a piece of paper and a pencil, and we can write stuff down," says Lynch. "It's all about ideas, and ideas stringing themselves together to make stories, or a mood, or whatever. It doesn't really matter what way you work, or what medium you work in, it's all about ideas. Sometimes ideas want to be furniture and sometimes they want to be a story in film." [viii]

This attitude is why Lynch has jumped from conventional filmmaking forms to creating pieces that don't subscribe to typical formatting: "I'm shooting a series called *Rabbits* with a tiny Sony PD-100, and when you see the quality, it's kind of fuzzy and kind of organic in a way. It's not bad quality, just different. So the tools start talking to you and you start getting images with that kind of quality in mind."

Rabbits is a web-only episodic series shot in the style of daytime soap opera and television dramas. It is a chamber piece given a typically surreal Lynchian twist by the actors wearing the appropriate animal masks. Its surreal nature is perfect for fans of Lynch's esoteric style, but its appeal is not broad enough for traditional moving-image distribution, either theatrically or via television.

"Every story, every idea wants to be told a certain way," Lynch says. These ideas need to be watched and distributed in a particular way, too. An all-digital workflow from filmmaker to audience allows for a greater variety of visions.

Lynch adds: "Now with digital cameras, the really great thing is the amount of control you have afterwards to fiddle around and start experimenting and get even more ideas."

Unlike Figgis, Lynch finds that the digital process presents the most freedom after filming has taken place. He is more interested in tweaking the image to fit the mood he wants to create, rather than concentrating on the performance while filming. This difference in emphasis is present in both directors' celluloid work, but digital filmmaking highlights the distinctions between their approaches.

Lynch asserts: "One of the more important things about making a film is that you want to limit the distractions so you can fall into that world and be able to focus. One of the nice things about working with the smaller cameras and smaller crews is that it creates fewer distractions and allows this to happen."
>>>

01

02

This wish to eliminate distractions is possibly why Lynch has become involved in using the Internet, and Macromedia Flash, this medium's specific animation format. He has used it to return to old ideas such as *The Angriest Dog in the World* (2002), a simple comic strip he originally produced for the publication *LA Reader*, and create new ones such as *Dumbland* (2002).

Dumbland is unlikely to win any prizes for animation, but as a short, brutalist form, the series does break ground. Animation would never have been allowed to be this disturbing when it was so difficult to produce. Lynch, confident in having the tools to single-handedly produce and directly distribute *Dumbland* to his fans, is able to generate work outside his usual spectrum of choice.

"Every story has its own feel, and film does talk to me. I love it," says Lynch. "Accidents can happen when there are so many steps to a process, and those accidents are sometimes really magical. With digital, I think the accidents happen later, when they go into the computer. It's a really great thing that you can just pump it into your computer, no scanning, no conversions, no worry about matching back out, and you don't need to deal with gate weave because it's already rock-solid. You can just shoot and then go to work in the computer."

>>>

"You can just shoot and then go to work in the computer. There's just more control in digital"
DAVID LYNCH

IMAGES

]01-08 [*Dumbland: a stark, nihilistic, and stripped-down animation created by Lynch for his website*

03

04

05

06

07

08

01
02
03
04
05
06
07
08
09
10

IMAGES

]01-15[*The Third Place: deep in Lynchian territory for PlayStation 2*

**FILM: THE THIRD PLACE
DIRECTOR: DAVID LYNCH
YEAR: 2001**

12

13

14

15

Lynch exemplifies that the digital generation of tools does not mean to, and should not, eliminate older analog formats when they are called for. Digital filmmaking purely extends the established filmmaker's palette.

The Third Place (2001), Lynch's UK commercial for Sony PlayStation 2, was an earlier oppportunity to put this theory into practice, using a prosumer DV camera and desktop digital editing software.

Lynch expounds on the benefits of working in this way: "There's just more control in digital. There's also more room for experimentation, and once you've learned these programs and they've become intuitive, I think that whatever you can think, you can get."

While the bandaged men and talking ducks of Lynch's imagination are a rare sight on television, the digital domain means more places than ever can store images from the dark corner. "This is the new TV," says Lynch of his online experiments. "They look as good on the Internet as they would on TV, so why would you go over to TV? TV is dead."

SOURCES

[i] *Interview: Holly Willis, Res (2000)*
[ii] *Interview: Andrew O'Thompson, ICG (2000)*
[iii] *The Language of New Media, Lev Manovich (2001)*
[iv] *Interview: Jerry Roberts, www.sonyusadvcam.com*
[v] *Hamlet on the Holodeck: The Future of Narrative in Cyberspace, Janet H. Murray (1998)*
[vi] *www.davidlynch.com*
[vii] *This format expansion is discussed further in Chapter 8, page 115*
[viii] *Interview: Scott Billups, www.sonyusadvcam.com (9/2001)*

ACCELERATED CINEMA
THE INFLUENCE OF MUSIC VIDEO DIRECTION

More crashes. More sex. More violence. More drama. More exhilaration. More fighters and lovers, gangsters and molls, pimps and hookers, winners and losers, heroes and heroines. More shooting. More shooting up. Hustle. Bustle. Sound and fury. Speed and movement. Most of all, more images. With contemporary lives set on fast-forward, avenues of cinema have advanced to reflect this rate of velocity. As viewers, we have all become used to assimilating larger amounts of visual data. Cinema has seen a concurrent adaptation to keep our appetites sated. If, as French philosopher Paul Virilio has suggested, the defining characteristic of contemporary life is speed, then it is this accelerated cinema that has evolved to harness this condition in moving-image entertainment. Accelerated cinema is relentless, sensational, and direct.

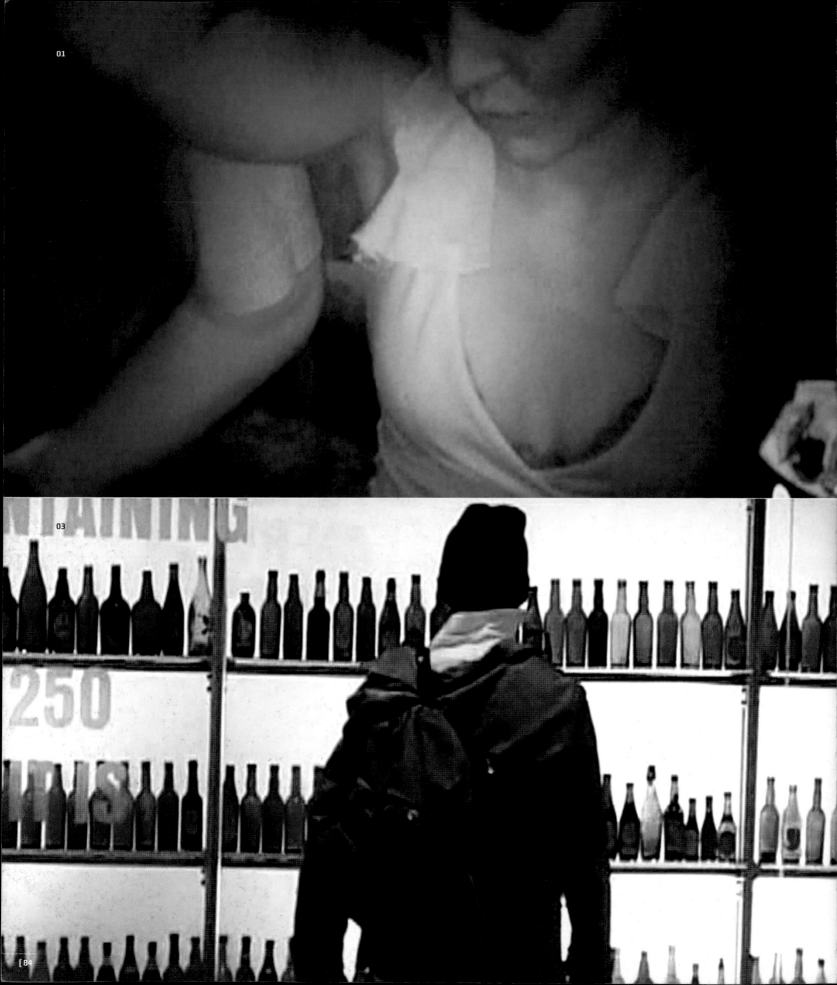

01

03

250

FILM: THE RULES OF ATTRACTION
DIRECTOR: ROGER AVARY
YEAR: 2002

The laziest phrase ever written in a film review must be: "I like an MTV music video." As in "X comes across like an MTV music video, on speed." ("On speed" being the next laziest.) As a film critic in the early 1990s, I never understood the phrase used by others in the profession. Was it an idle insult or simply an attempt to encapsulate something an older generation of critics could not understand?

The influence of music video direction, far from being something invidious and degenerating for the cinema, has been essentially invigorating to an art form entering only its second century. Music videos have successfully turbocharged cinema. The best directors of this form, such as Michel Gondry, have made miniature epics flooded with ideas (witness his coruscating, motion-bending, time-sliced Smarienbad Smirnoff commercial, or his temporally warped *Sugar Water* promo for Cibo Matto), which have soon infused the big screen.

If we think of *Fight Club* (David Fincher, 1999), of *Natural Born Killers* (Oliver Stone, 1994), or even of a modern historical epic such as *Gladiator* (Ridley Scott, 2000), these could not have been made in a visual culture that hadn't become used to the supra-montage of the music video world.

Roger Avary's feature film adaptation of the Bret Easton Ellis novel, *The Rules of Attraction* (2002), is a prime example of a modern feature that borrows heavily from this sphere in its form and effects. Successfully portraying the vapidity, amorality, and sheer senselessness of college life, the film's *tour de force* moments include the "Dress to Get Screwed Party," which is told from multiple viewpoints with a remixed timeline, events flash-forwarding and playing backwards. Thus the scene offers a surprising moment of humanity as we follow the two protagonists, in split-screen, across campus until they meet, when the screen artfully resolves back together.
>>>

IMAGES

]01-03 [*The Rules of Attraction: a DV montage trip around Europe captures the original Bret Easton Ellis novel's exploration of decadence and vapidity perfectly*

01

02

A minor character, Victor, has left to travel Europe, and this story is retold as a short but memorable hyperkinetic digital video sequence. It is this sequence that offers the most quintessential experience of accelerated cinema.

Avary explains the result of the filming process in a magazine article: "When I return home to finish post-production on *The Rules of Attraction* I find myself sifting through more than 70 hours of DV footage—that's as much as I shot of 35mm film for the movie itself. While cutting it down to the four minutes you see in the film I discover that I've essentially shot an entire secondary film, complete with scenes, dialog and character arcs. I begin cutting it together as a feature film separate from *The Rules of Attraction* and *Glitterati* slowly begins to emerge and take form." [i]

In condensing this two weeks of filming into those few minutes for *The Rules of Attraction*, Avary distills the exhilaration and abandon of Victor's trip. He communicates the feeling of "flow," the experience of losing oneself in the action, being unselfconscious and totally absorbed, that has been defined by psychologist Mihaly Czikszentmiyalhi [ii].

It will be fascinating to see the expanded experience of this freeform filmmaking in *Glitterati*, and follow a real-life instance of screen bleed—where the actor Kip Pardue (who played Victor), stepped out of the frame, and stayed in character for this period of fantasy reportage.

Avary's next planned film (an adaptation of another novel by Ellis) *Glamorama*, also features Victor. By seeing *Glitterati* as a bridging film, the director extends the narrative so it can become, between the two "main" features, part of the fabric of our existence. The supra-montages of *The Rules of Attraction/Glitterati* break down the screen's barriers.

Nowhere has this breaking of boundaries been made more explicit than in a scene in *Fight Club* in which the character Tyler looks at the camera lens, not at the audience, but just beyond the lens to the film. He grabs this strand of celluloid moving through the gate, snatches at it, shakes it. We've gone beyond the floating rectangle; it has been superseded by the agitated frame. The action is a direct provocation to the viewer.

>>>

IMAGES

]01-03 [*The Rules of Attraction: a film in which everyone is furiously searching for something*

MUSIC VIDEOS: WINDOWLICKER, DRUKQS
DIRECTOR: CHRIS CUNNINGHAM
YEARS: 1999-2002

The hyperkineticism of accelerated cinema can be seen as the visual equivalent to the sound barrier. As the images increase in their speed and intensity, they hit our optic nerves and cause a kind of mental boom. Transcending both recognition and thought, the images and feelings flow. Don't fight it, feel it. This type of cinema is all about evoking a state of mind, a sensation. It is defiantly not about contemplation or deliberation.

Although he is yet to make a conventional feature film, Chris Cunningham, best known for creating some of the most powerful and enduring images in music videos, has built a formidable reputation for creating moving image with astonishingly distinctive emotional and visual textures. He has been fortunate enough to marry his visuals to extreme tracks of experimental electronica music artists. In so doing he has created capsule epics in the music videos for Aphex Twin, *Come to Daddy* (1997) and *Windowlicker* (1999), and Squarepusher's *Come on my Selector* (1998). These reduce a sundry array of genre movie motifs—inner-city horror, R 'n' B musical, asylum sci-fi—into concentrated, ultra-synchronized montages.

Cunningham's films may exist at one and the same time as homage and parody of a narrative level, but visually they transcend the rational. They are archetypal synaesthetic creations. The word "synaesthesia" blends the Greek "aesthesis" (sensation), and "syn" (together, or union), implying the experience of two, or more, sensations occurring together [iii]. It generally describes a sensory behavioral interpretation that transfers sound and color. The Germans call it *farbenheren*; the French call it *audition colourée* (both terms means "colored hearing.")

Cunningham's interpretations are groundbreaking executions; contemporary updates of Eisenstein's "color-sound montage." Eisenstein was adamant that there existed no "all-pervading law of absolute meanings and correspondences between colors and sound." Nonetheless, synaesthesia had a big influence on his work.

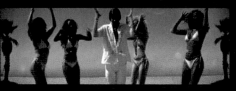

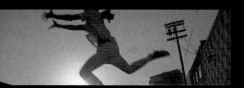
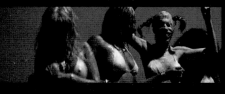

That influence is still increasing. The way that digital moving image allows the manipulation of the media to elicit these sensory fusions makes it easy for artists to create work that emulates these qualities, and feeds the audience's appetite for entertainment that offers these sensations.

Bill Viola, the video artist (see page 168), has made some pertinent observations in this area: "Efforts with artificial technology have made it necessary to distinguish between synaesthesia as an artistic theory and practice, and synaesthesia as a genuine subjective ability or involuntary condition for certain individuals. There is a natural propensity in all of us to relate sound and image. The beauty of these experiences is in their fluid language of personal imagination, and in their ties to mood and movement." [iv]
>>>

IMAGES

]01[*Drukqs: teaser for Aphex Twin album, featuring a digitally manipulated Chris Cunningham*
]02[*Windowlicker (Aphex Twin): a captivating parody of typical R 'n' B videos, filmed in the glare of the LA sun*

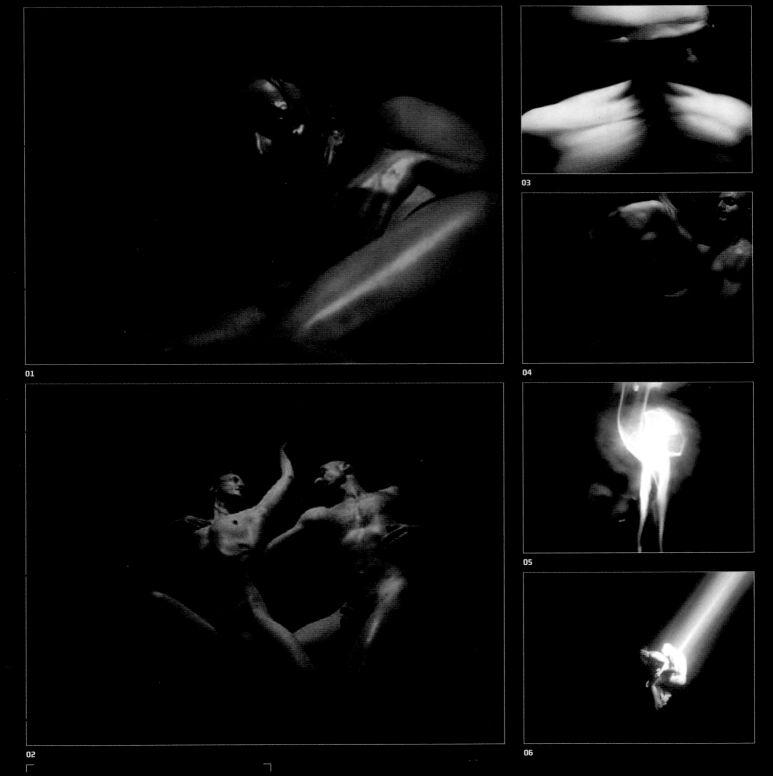

01

02

03

04

05

06

Cunningham has half jokingly suggested that pornography and technology are his biggest influences

08

09

07

**VIDEO INSTALLATION: FLEX
DIRECTOR: CHRIS CUNNINGHAM
YEAR: 2000**

This relation between sight and sound can
be seen in *Flex* (2000), Cunningham's video
piece commissioned by the Anthony D'Offay
Gallery. It is an extreme extension of the
visual ideas he first explored in the Portishead
music video, *Only You* (1997). A light starkly
illuminates a man and a woman, floating
in a black vacuum, naked and vulnerable,
accompanied only by an uncompromising
texture of electronic sound that eerily mirrors
the action on screen. Sheered of extraneous
detail, the video exposes a nerve, and
leaves an aftertaste of violence and dread.
Cunningham has half-jokingly suggested that
pornography and technology are his biggest

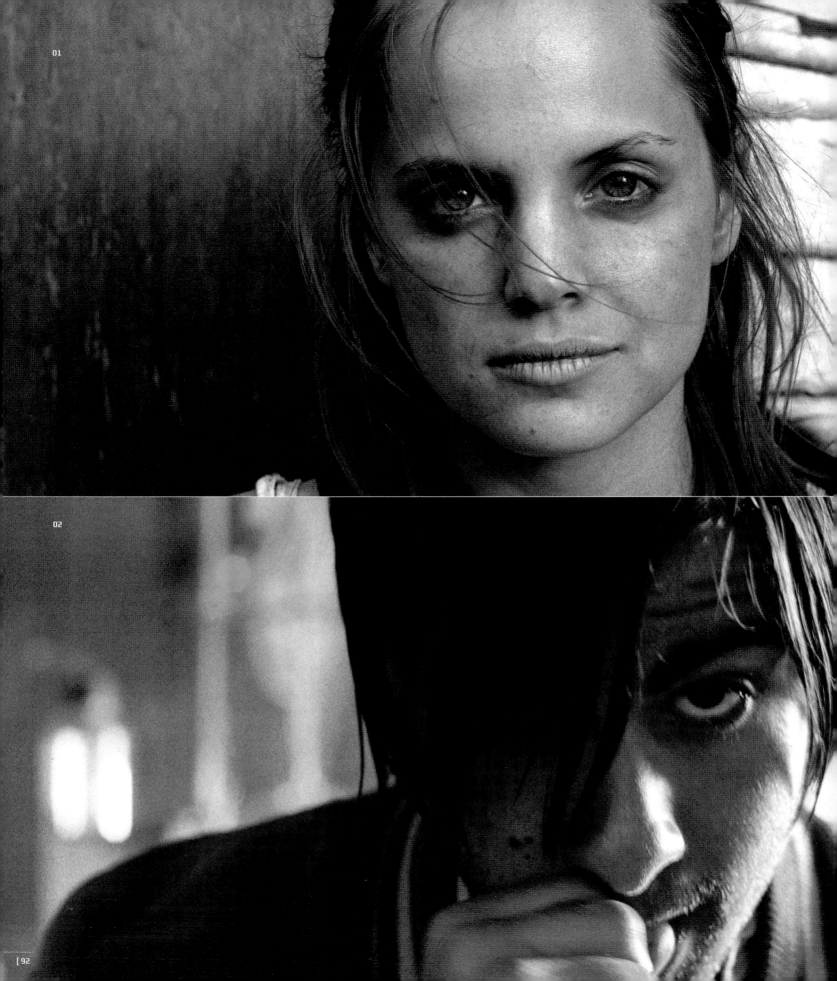

**FILM: SPUN
DIRECTOR: JONAS ÅKERLUND
YEAR: 2002**

The cult Japanese shocker, *Tetsuo: Iron Man* (Shinya Tsukamoto, 1988) and its sequel, *Tetsuo II: Body Hammer* (1992) demonstrate an unadulterated pleasure and intensity in the image, while the films of Wong Kar-Wai, such as *Chungking Express* (1994), and *In the Mood for Love* (2000) offer no less a restrained vision of lush visual gratification but accomplish it in a more elegant fashion. Their visual communication is far more complex than the story. These films rely on the narrative being supplemented and driven by imagery. We are moving to a cinema of abstraction. Faced with this maelstrom of images, it is no wonder that context is drawn down to emotional essences.

This can be seen in music video director turned feature filmmaker Jonas Åkerlund's first feature, *Spun* (2002). Detailing a crystal meth-fuelled three-day bender, it is an appropriately chaotic series of disjointed vignettes and hallucinogenic encounters. Story is secondary in this movie. *Spun* is all about a spiralling mood, communicating a narcotic jumpiness in, according to the director, an extraordinary 5,345 cuts.

>>>

IMAGES

]01-03 [*Spun: jittery, unflinching camerawork and editing mirrors the film's raw, urban subject matter*

So, is this all sleight of eye to distract us from the screaming, gaping void behind the picture? All surface, no depth? Well, real life is not made of character arcs, of plot points fitting neatly into three-act structures, so why does cinema have to be like this all the time? Accelerated cinema is defiantly non-naturalistic, or what we have been accustomed to consider naturalistic on-screen. Which is all that matters. This cinema of abstraction could be an enterprising reaction to information overload. Umberto Eco, the Italian novelist and cultural commentator, observed that the pop song is evolving as a vehicle toward the ultimate chorus, a point at which the listener is overwhelmed by emotion [v]. Accelerated cinema suggests the same may well be happening in moving image.

IMAGES

[01-02] *Spun: an intimate, non-naturalistic cinema bringing the viewer too close for comfort to the white trash milieu*

SOURCES

[i] *"Sex, Lies and Videotape"*, Roger Avary in Arena magazine, (5/2003)
[ii] *Creativity: Flow and the Psychology of Discovery and Invention*, Mihaly Czikszentmiyalhi (1996)
[iii] *Synaesthesia: The Strangest Thing*, John Harrison (2001)
[iv] *"The Sound of One Line Scanning,"* in *Reasons for Knocking at an Empty House: Writings 1973–1994*, Bill Viola (1995)
[v] *Travels in Hyperreality*, Umberto Eco (1986)

QUICK ON THE DRAW
THE RISE OF ANIMATION

It was at one of the gigantic screens at the Pathé cinema complex, at the International Film Festival in Rotterdam in the late 1990s, that I had an ocular epiphany. It was there that I witnessed the most jaw-dropping, eye-popping animation I had ever seen: Noiseman Sound Insect (1997) by the Japanese director Koji Morimoto. It transformed my view of animation. Now, animation is extending beyond the archetypal hyperreal fantasies of anime, beyond the cornbred purity of Disney, into the mainstream of storytelling media.

FILM: NOISEMAN SOUND INSECT
DIRECTOR: KOJI MORIMOTO
YEAR: 1997

02

Of course, I knew startling things were
happening in anime (Japanese animation);
I had already seen Katsuhiro Otomo's *Akira*
(1988) on its first cinema run at London's ICA.
Koji Morimoto had worked as an animation
supervisor on this seminal, blockbusting
animation, which gave an early indication of
his talent. Nearly a decade later, with his
direction of *Magnetic Rose*, one of the three
episodes in Otomo's portmanteau film,
Memories (1996), Morimoto was entering even
more illusory territory.

In creating *Noiseman*, he demonstrated how
anime could show us much more than the
typical hyperreal dystopias and *fin de siècle*
fantasies. By all accounts, I am not the only one
who has been so affected by coming into
contact with this mysterious and seldom-seen
film. Since a limited series of festival showings,
it has hung in a distribution limbo, helping it
gather a mythical reputation. Finally, that
could change and it may be introduced to a
much wider sphere of viewers, as Morimoto's
Studio 4°C released a Japanese DVD edition in
2003, international release will hopefully follow.

IMAGES

]01-02[*Noiseman Sound Insect: concept sketches*
]03-09 & OVERLEAF[*Morimoto conjures up a beautifully
animated contemporary fairytale*

04

07

The 16-minute short is a surreal masterpiece, centered in the beautiful and dreamlike city of Cahmpon. Here, a scientist creates an artificial life-form, the eponymous Noiseman. This creature sucks up sounds and transforms them into crystals, until a group of street kids in the besieged city fights back against this aural oppression, risking being transformed into strange sound creatures themselves along the way.

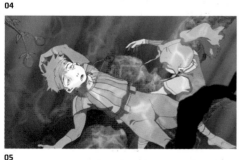

05

08

The subject perfectly mirrors how Morimoto creates his work—more intuitive than rational. He uses music as part of his way of working to create a mood that corresponds to the scene to be completed, and, after an hour or so of listening to these sounds, he starts to draw. His animation is highly interpretative; he is able to inhabit a mental zone of dreams and non-logic, and to evoke the same in the viewer. This is an immense task considering the highly technical nature of contemporary animation, with its fusion of 2D and 3D techniques, of hand-drawing and computer-generated visuals.
>>>

06

09

**FILM PILOT: TEKKON KINKREET
(BLACK & WHITE)
DIRECTOR: KOJI MORIMOTO
YEAR: 1999**

Disney, Dreamworks, and even Pixar are still extending a decidedly traditional notion of figurative animation (despite their astonishing technical advances). Yet Morimoto's work, as well as that of contemporaries like Satoshi Kon (with whom he worked on *Memories*, and who later created the animated psychological thriller, *Perfect Blue*, 1997), serves to illustrate a highly mature and adult interpretation of the medium—a direction that is nuanced, imaginative, and humanistic.

In citing Tarkovsky, the Russian director of

While *Tekkon Kinkreet* has not yet moved further than being a trailer, *Beyond*, *The Animatrix* (2003) episode that he directed, is arguably the most fully realized of the short films in this collection of spin-off animated films based in the Matrix universe (see page 46). It has its own sense of place and awareness beyond the confines of the parent films, their genres, and plots. In it, a young child, Yuko, discovers a glitch in the Matrix that causes a bizarre time/physics distortion in a "haunted" mansion. Yuko and friends enjoy a playful break there before the system fault can

SHORTS: SNACK & DRINK,
FIGURES OF SPEECH
DIRECTOR: BOB SABISTON
PRODUCER: TOMMY PALOTTA
YEARS: 1999–2000

At the opposite end of the spectrum to
Morimoto's flights of fantasy is the equally
original fusion of the disciplines of animation
and documentary created by the directing and
producing team of Bob Sabiston and Tommy
Palotta. They came to prominence through the
short film *Roadhead* (1999), which garnered
acclaim at film festivals around the world. In
Roadhead, they took a trip from New York to
Austin, Texas, filming interviews with a variety
of people on their pitstops, using a DV
camcorder. The film gives a flavor of the
characters through an assortment of
animated styles, by a range of artists.

"Our films have no single style or coherent
character design," the filmmakers say, rather
disingenuously. "Instead, the artists working
on our films are encouraged to use their own
personal voices in creating individual scenes.
Thus, the films produced are not animated in
the truest sense of the word; they are
composites of wildly different, reimagined
video scenes rendered in a vivid cartoon style."

03

04

01

05

06

07

The trademark animation style Sabiston and Palotta evolved from *Roadhead* resulted in *Snack & Drink* (1999), another short—which follows Ryan Powers, a 13-year-old autistic boy down to his local convenience store to get a unique food and beverage combo—being admitted to MOMA's permanent collection. The fluid, vector-based animation was created using Sabiston's own custom-made software tool, Rotoshop—so called for its streamlining of the rotoscoping process for animators. He describes it as "Photoshop for animators," as it interpolates frames between key drawings to aid the artist using it to create a highly distinctive floating and fluid animation.

As Sabiston explains: "The rotoscoping technique itself is applicable to any style of animation, and therefore any type of movie. Fantasy and science fiction movies would probably do well with it. However, personally, as far as the things I want to animate, I think I still just like the animation of personality-character portraits. The human face remains the most fascinating thing to me, as far as things go that change frame-to-frame." [i]

By filming DV footage of interviews and scenes, and then using these as a basis for the animation, Sabiston's animations are moving paintings in the truest sense. They offer a highly personal interpretation of the world. In *Figures of Speech* (2000), a series of straight-up interviews on PBS (the Public Broadcasting Service), it is clear that watching animated characters "act" so naturally is a valuable and subtle alternative to the kinetic bluster of kids' cartoons.
>>>

IMAGES

] 01-05 [*Snack & Drink: kaleidoscopic animation meets documentary short, creating a unique look at the existence of the autistic subject, Ryan Powers*
] 06-07 [*Figures of Speech: PBS short interviews, animated using Sabiston's custom-made "Rotoshop" software*

"*This movie wouldn't have worked with traditional animation… I wanted this kind of animation because it's reality based*"

RICHARD LINKLATER

FILM: WAKING LIFE
DIRECTOR: RICHARD LINKLATER
YEAR: 2001

The unique qualities of the "rotoscoped" animation are no doubt one of the reasons why filmmaker Richard Linklater—with naturalistic films under his belt such as *Slacker* (1991), *Dazed & Confused* (1993), and *Before Sunrise* (2000)—collaborated with Sabiston as art director on *Waking Life* (2001), the first independently produced feature-film animation.

Waking Life is a stunning take on reality as filtered through the dream-states of the lead character, who wanders through Austin, Texas, taking in insightful vignettes and poetic ramblings from the town's inhabitants. This improvizational style and wordy script, running through diatribes on technology, god, the purpose of life, and the constituents of memory, is reminiscent of Linklater's early cult film *Slacker*, but gathers a more prophetic and universal dimension through the characters and thoughts being abstracted through the animation.

Linklater expounds on his use of animation: "This movie wouldn't have worked with traditional animation... I wanted this kind of animation because it's reality based. I wouldn't have made it otherwise. I never thought about making an animated film, I'm not an animator. It was the human quality of this that kept me going." [ii]

There have always been original visions in animation, stretching from the abstract dimensions of *Fantasia* (1940), right up to the recent Oscar-winning *Spirited Away* (2002) by Hiyao Miyazaki, but its increasing accessibility to creators and acceptability by viewers is fueling animation's colonization of new genres. Its infiltration of other bodies of moving image shows no sign of abating.
>>>

IMAGES

]01-03 & OVERLEAF [*Waking Life: a feature-length animation pushing the boundaries of the medium by redrawing real actors' performances*

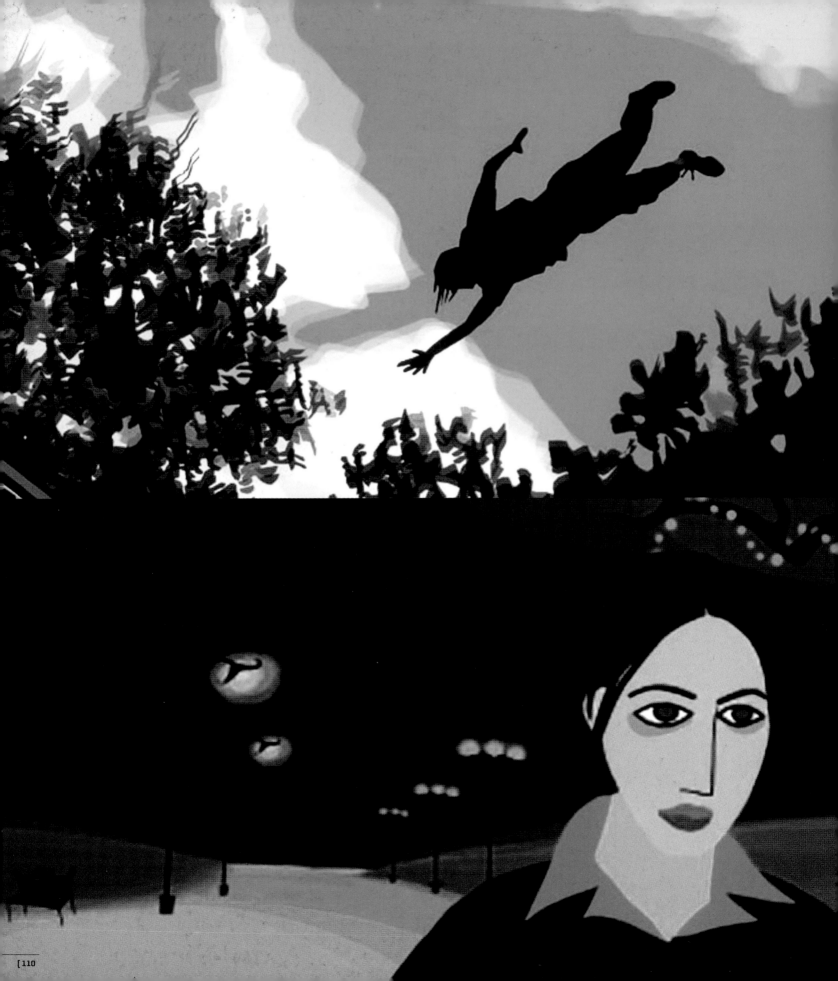

Its increasing accessibility to creators and viewers is fueling animation's colonization of new genres

FILM: EYE FOR AN EYE (UNKLE)
DIRECTOR: SHYNOLA,
RUTH LINGFORD
YEAR: 2001

Directing team Shynola's *Eye for an Eye* (2001)
music video for UNKLE exemplifies how
animations with enough ambition used in the
music industry can become more than
promotional pieces. In this case, it acts as a
powerfully dark fairytale and anti-war film.

Snatches of interpretative animation in
feature films such as Oliver Stone's *Natural
Born Killers* (1994) and Quentin Tarantino's
Kill Bill (2003) demonstrate that it is becoming
an integral part of serious filmmakers'
palettes. Animation is drawing us into new
realities and further into fantasy.

02

03

IMAGES

]01-05 [*Eye for an Eye: a music video becomes an anti-war
animated short that extends its remit beyond that of band
publicity to political statement*

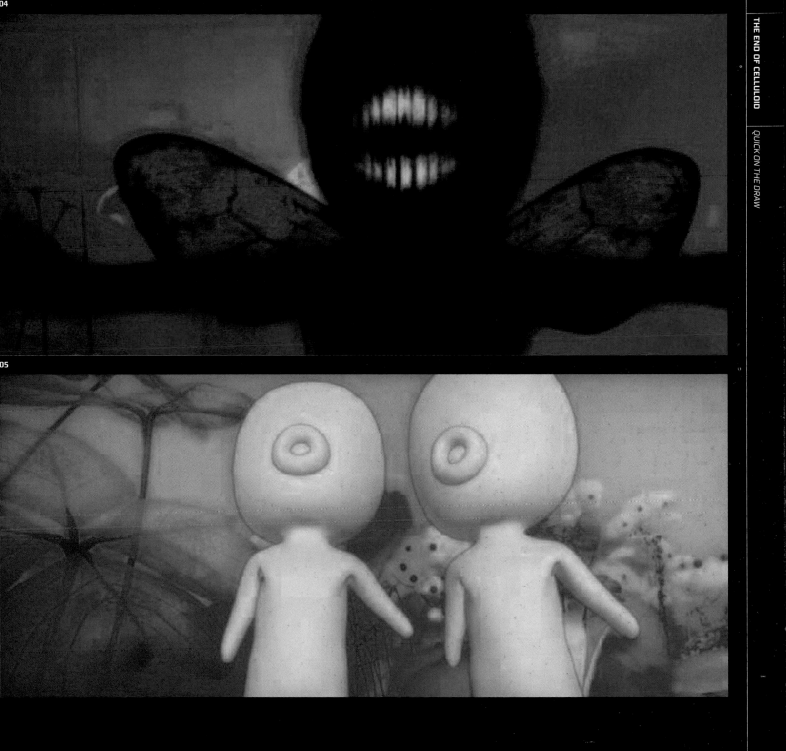

SOURCES
[i] *Interview: Dave Filipi, The Film Journal, Ohio (5/2002)*
[ii] *Interview: Bec Smith, www.if.com.au (12/2001)*

20:51
218168
♥ 100

linear del juego y explore "ejados, gocé de los anuncios del s

detallados están producidos com

ios El IU", me hice un skin de turista cana

THE ETERNAL GAZE
THE FUTURE OF
AUDIOVISUAL CONSUMPTION

I'm in a neon-soaked Miami. Tonight the light hangs in the air; everything feels hot and humid and diffuse. A light breeze whips in from the ocean. A good night to have some fun. Cruising down the seafront in a shimmering black SUV, I notice an empty drugstore. An opportunity. I hop out, flexing my fingers around a trigger and, in an instant, I'm holding up the guy behind the counter. He cowers, handing over the dollars. Alarms sound, I dive into the car, slamming the accelerator. It's only taken a few seconds and I'm being pursued by a surfeit of cop cars. I quickly lose two, ramming them into the canal. Gotta ditch the car for something more suitable. I head for heavy traffic. Hitting the highway, I hit pause; time for a breather and to lift off the Olympus Eye-trek goggles. Return to reality from the ever-more immersive hardware and software entertainment world.

What I've been watching, indeed controlling, is *Grand Theft Auto: Vice City* (2002), a video game shortlisted for the inaugural UK Designer of the Year awards 2003. The game is the current *ne plus ultra* of explorable environments. There is a pleasure in not just exploring and interacting with this mutable environment, but also in just watching it; experiencing it fill one's whole field of vision. It may not be the most realistic or large-scale gaming environment ever created, but it stands up as the most user-friendly and most enjoyable that I've surveyed.

Using the Olympus goggles (Jaron Lanier, the father of "virtual reality," called these "eyephones," a somehow more faithful description), with two tiny LCD monitors right in front of each eye giving the illusion of watching a 62-inch TV screen, the visuals are slammed down the retina. Along with the stereo sound from the headphones, it makes for an all-engulfing experience, different from viewing television, more like a private cinema. But using these glasses hooked up to a games console is only an indication of how the next wave of audiovisual innovation—both in hardware and content—will shatter our conventional consumption of visual entertainment, and the present domination of traditional formats. Advanced hardware will be complemented by advanced moving image. Welcome to the era of the eternal gaze, where we will always be watching.

Getting back to the design competition, the winner of those awards was Jonathan Ives, the head of design at Apple, who successfully transformed computing equipment into more digital lifestyle-friendly formats. In particular, the Apple iPod, its highly successful MP3 player, has revolutionized the way that people consume their music collections. With differences in bandwidth, capacity, and other technical issues, technology usually impacts on music before progressing to moving image, when the equipment has incrementally improved enough to tackle the media's enhanced requirements.

Moving image hardware is now not far behind audio, and these contemporary products are the gathering clouds, marking the death knell for traditional media formats. Whether it's the iPod DV, an Achos Media Jukebox, or a similar device by a consumer electronics manufacturer, the arrival of appliances that allow us to alter our traditional viewing experiences is changing the way we see. This alternative hardware—including Personal Video Players (PVPs), recordable DVD, and video hard drive recorders—heralds a long overdue adjustment in our relationship with film, and they act as the ultimate catalyst for the transformation in moving image formats and genres that many moving imagemakers and viewers have been waiting for.

The innovation in moving image facilitated by Quicktime, the *lingua franca* of digital media, can migrate from the Internet and P2P (peer-to-peer) networks to these new devices, ushering in the mainstreaming of traditionally marginal visions.

The turnover in these technologically cutting-edge devices is frighteningly fast, but as the feature set matures, it is only the storage, running time, and other technical issues that are being constantly upgraded. Now we are at a tipping point where these screening devices are providing a revolution in audiovisual experiences for the masses.

Sony's PSP (PlayStation portable) mobile gaming device, its "Game Boy killer," has been announced for release at the end of 2004. Utilizing miniature portable storage—such as the new universal media disc (UMD) and solid state memory sticks—it offers the promise of a genuinely convergent entertainment tool, providing both moving image playback and gaming. It also suggests hybrid possibilities between the two.

The declared wireless functionality and infrared connectivity may allow filmmakers to explore the more social implications of sharing, and acquiring new moving image content. Portable devices' many possibilities include the production of site-specific moving image—films that interrelate with the environment. This should create more instances of screen bleed (see chapter 4), the fantasy moving image world melding with reality and vice versa. Some fascinating experiments are beginning to happen in this area, such as with the video walks of artist Janet Cardiff (see page 160). Imagine what will happen when more of us have a Vaio PVP.

Devices like PSP accelerate the process of upgrade in our moving image experiences. We now expect moving image to be shaped by our will, as much as it can alter our views, and offer us different viewpoints on the world. These different viewpoints can be seen literally with the success of DVD. As the fastest adopted consumer electronic device ever, DVD is a Trojan horse for the advent of advanced moving image in the home.

A late 2003 Forrester research report suggests that it will soon be superseded by video on demand (VOD) for delivering feature film screenings straight to the home. But it has inherent advantages that will be enhanced by a turbocharged successor such as Blu-ray disks, or another competing disk format, but not by VOD. The research assumes the viewer is content to carry on being fed homogenous, format-static product by Hollywood. The rise of computer games shows that the watcher is never content, and new modes of seeing won't be fulfilled by VOD unless this downloadable content morphs its current form, too.

DVD will become expanded DVD. DVD releases such as *My Little Eye* (see page 14) illustrate the possibilities outside the realm of the ubiquitous director commentary, quickly-assembled electronic press kit (EPK), deleted scene or "making of" featurette. *My Little Eye*'s extension of the story's surveillance scenario to include alternative audio from the guards controlling the house, and alternative "webcam" footage surveilling them from various angles, allows the viewer the spatial exploration and control usually associated with computer gaming.

Porn was the first genre to capitalize on the obvious features of multiple viewing angles built into the DVD format, but more emotional mainstream responses have yet to be investigated. These alternative angles provide an optic shift, a different perception on proceedings, that filmmakers have only just started to explore, but that fans of first-person shoot-em-ups and driving games are all too familiar with. Think of it as Akira Kurosawa's *Rashomon* (1950) imploded and folded in on itself.

>>>

01

02

03

IMAGES

]01-03[*Radiohead TV: idiosyncratic streaming Internet TV channel*

When the VCR was invented, Sony's Akio Morita announced the arrival of "time shifted" viewing. Panasonic have updated this with the ability to watch and record content at the same time as "time slip." But these servers go beyond shifting and slipping the way we view to the way we experience. The hardware is on the way to destroying the principal moving image formats of feature film and broadcast television, to offer a more fragmented and diverse space of moving image possibilities. Home entertainment servers will store and deliver us new media possibilities we may never have thought of—pushed content that acts as a springboard, a nexus for capsule narratives, and extensible stories.

Sony is aggressively moving into the market to capture these "visually intelligent" users of moving image who roam between watching and playing. Their PSX is a wolf in sheep's clothing, a grown-up PlayStation2, merging broadband and DVD functions with the additional attributes and looks of a home entertainment center.

Paradoxically, the rise of multiple-media platforms has seen, in the short term, increasing consolidation in dominant formats, of features, and, in episodic television, event programming. These formats were in a strong market position to extend their reach into these emerging platforms from the outset, but they are not next-generation content. These formats will have to adapt, mutate, and be reinvented to fulfill our new entertainment needs. All programming will need to be personal, practicable, or an event for the recipient. The eternal gaze is also a roving one, searching for the most intense.

That is why personal video recorders (PVRs) are such a hit with users. TiVo pioneered the idea of Me TV, a remote agent gathering and recording moving image according to your stated preferences, and also inferring these from manual recording choices. The TiVo technologies delivered by satellite set-top boxes such as Sky+ or DirecTV are destroying the idea of TV broadcasting. Digital TV's red button is the self-destruct for network broadcasting (a survey at the 2003 Royal TV Convention shows that even 39 percent of industry delegates accept the coming death of linear TV [i]). The proliferation of digital channels are chasing the narrowcasting dream of devoted niche audiences, but the real action lies with our own personal channels, enabled by Microsoft Media Centers and home entertainment servers like Sony's Cocoon.

The possibilities of the hardware await the creation of new forms of malleable media. "Time squeeze," a concept proposed by Jane Pavitt [ii], in which our leisure time is compressed, means that entertainment formats need to evolve so that they can be watched in compressed, non-sequential, or in differing ways according to our time allowance. Squeezable formats such as micro-movies will move from the Internet to populate all screens. Rapidly digested, sensation-based blipverts (condensations of accelerated cinema)—already seen in the music video field with Radiohead's blips and Radiohead TV online—will color and infuse longer viewing while standing alone as bite-sized entertainment. The master Argentinian short story writer Jorge Luis Borges [iii] proposed webs of fantasy worlds; narratives of forking paths. Collections of these compressed moving images make up larger visual topographies. This hypermedia awaits its audiovisual Borges.

>>>

IMAGES

]01-03[*Radiohead Kid A Blipverts: worlds of experience eliciting capsule narratives, easily digestible for speedy, on-the-move consumption*

02

03

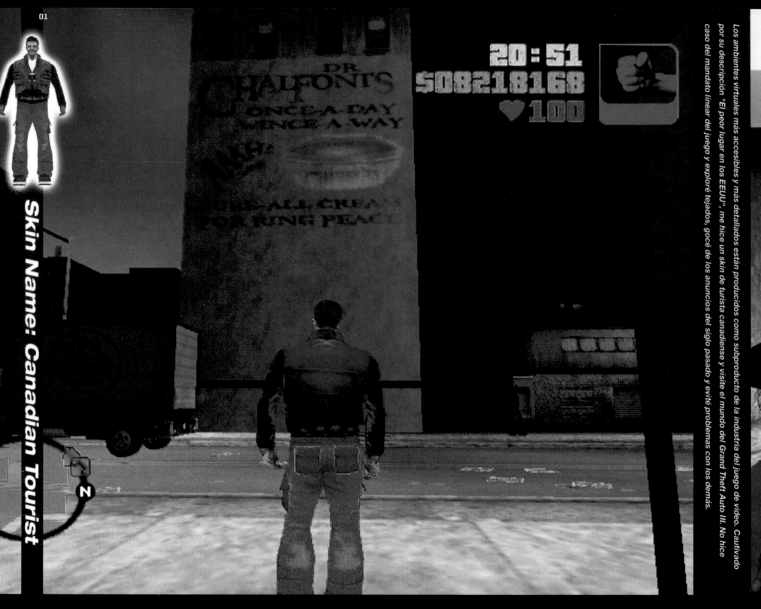

01

20:51
$08218168
♥100

Skin Name: Canadian Tourist

my trip to
liberty
city

Subverting moving image and visual software, interchanging it; making it alterable; making it a deep experience that is consequently personal, mysterious, and voyeuristic—that is the adventure. Patterns of behavior are altering, though: back to the pleasure of persistent environments, and *Vice City*. As one of the few games that is as pleasurable to watch by non-player spectators as it is to play, it in effect creates an instant movie. *My Trip to Liberty City* by Jim Munroe [iv] is available on the Internet as one such recorded adventure in the city. The Internet as a repository for these alternative viewing experiences will be superseded by home entertainment networks and viewing devices. Viewers are claiming the moving image for themselves.

One frame size does not fit all. Ideas are not constrained by the boundaries of the screen. Moving images freed from standard television resolutions also become independent of the dominion of the predominant content formats and genres. New content forms express themselves more willingly on these devices, because these new AV devices "dream" different media.

This idea of dreaming is one posited by designers Anthony Dunne and Fiona Raby in their development of concepts such as "design noir" and the "electrosphere" [v].

Design noir, derived from the moral ambiguities of film noir, allows us a space to think; to imagine what new interrelations we can have with an object. It's a technique that moving imagemakers could well apply to what forms content could take that will inhabit our new screening devices. The electrosphere, the idea of a third space, where the object mediates and influences social, psychological, and cultural experiences, elicits crucial issues about how much entertainment we can take before our sense of reality diminishes too far.

As Dunne explains, "Screens are like 'supermatter': once switched on, all attention turns to them, and their material qualities are demoted to the status of package or container as the viewer searches for the real content, information."

Different modes of seeing demand different devices for optimal experience, from the theatricality and immensity of the blockbuster on the cinema screen to the intimacy of the PVP. The access that this array of AV devices gives us, alongside our mainstream media, to new *samizdat* (underground) visual data and alternative visions has implications beyond the realm of entertainment. It becomes a frontier of new sights, spectacles, and revelations.

SOURCES

[i] *"The End For Who?" Media Guardian* (22/09/2003)
[ii] *Brand New, Jane Pavitt* (2002)
[iii] *Collected Fictions, Jorge Luis Borges* (1999)
[iv] *My Trip to Liberty City, Jim Munroe,*
www.Nomediakings.org
[v] *Hertzian Tales: Electronic Products, Aesthetic Experience and Critical Design, Anthony Dunne and Fiona Raby* (1999)

ACTING UNREAL
PART 1: EGOLESS STARS
PART 2: RELIVING HISTORY

While to some the digital world holds the fear of identity theft, to others it is a route to freedom, beyond physical boundaries. For a person with physical disabilities it may allow a zone of exploration free from people's preconceptions. For a celebrity, it may be another example of fame disenfranchising them from their image, another part of them stolen by the public domain, or the ultimate means to transform into an icon.

EGOLESS STARS

Digital effects pioneer Jeff Kleiser invented the term "synthespian" when he created Nestor Sextone, the first digital actor, for his short film *President* (1988). Since then, the special effects industry's holy grail has been to produce a convincing digital copy of their leading actors and actresses to allow them to seemingly perform stunts that insurance companies would never allow, or undergo transformations that would be unconvincing if performed traditionally. No doubt, the secret motive is to replace the actors totally.

Recreating real-life movie stars is fraught with difficulty. After all, humans specialize in studying each other's faces. We know when something or somebody is trying to dupe us. There seems to be a glass ceiling when it comes to creating virtual humans—often called "avatars" in the Internet or multimedia domains. Researchers have found that people respond to the increasingly lifelike nature of these avatars up to a certain point. They've identified that, once a point of near-naturalism occurs, favorable reactions to these avatars drop. Informally called the "zombie zone," it happens when expectations about what we consider human are violated—our senses are alarmed by any actions that do not ring true and defy our belief in the avatar.

The beguiling thing is that virtual actors are more convincing and entertaining when they are made from scratch, rather than being based on real-world models. When they are true to themselves without aping every human tic and gesture, our brains are very good at filling in the blanks; filling in the reality. So it is that certain virtual actors that resonate with viewers are turning into digital icons, colonizing feature films, and, in a reversal of roles, being "played" by human movie stars— Lara Croft was created as a gravity-defying, digital über-babe; Angelina Jolie had to work on her physique to play the role. Avatars take on a life of their own.

Not only are virtual actors convenient, they don't request special catering, demand an extensive entourage, or (not just yet, at any rate) a return of the gross alongside an inflated pay-or-play deal. Paradoxically, in a world with an insatiable appetite for celebrity news and gossip, the appeal of these virtual icons lies in their aloofness—above the banalities of actual human existence, they are the perfect empty vessels onto which we can project our own hopes and fears.

In a world of identikit beauty—square jaws, chiselled cheekbones (often literally), arched brows—virtual actors exhibit charm and charisma because of their difference in design and behavior. These are characters such as Link (*Legend of Zelda*, 1986), Mario (*Mario* series, from 1996), Parappa (*Parappa the Rapper*, 1996) and Vibri (*Vib Ribbon*, 2000), not to mention the more humanoid clones in the vein of *Metal Gear Solid*'s Solid Snake, *Tomb Raider*'s Lara Croft, and *Final Fantasy*'s Aki Ross.
>>>

IMAGES

]01[*Metal Gear Solid 2—Sons of Liberty: ninja avatar*
]02[*Solid Snake*

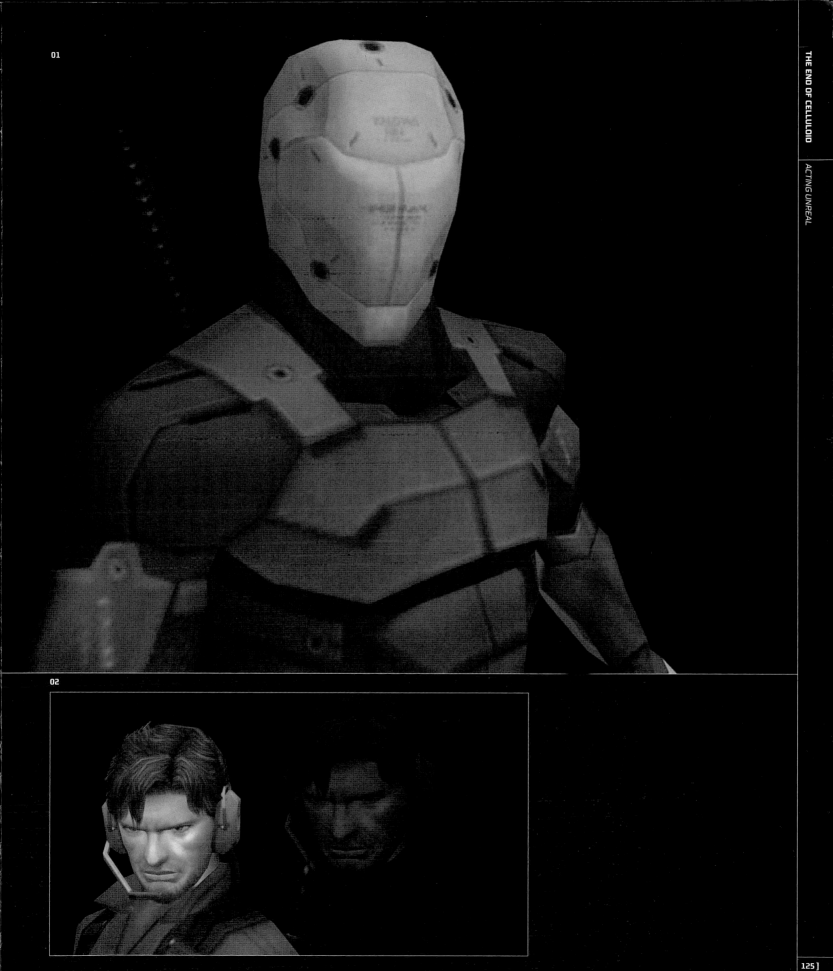

01

02

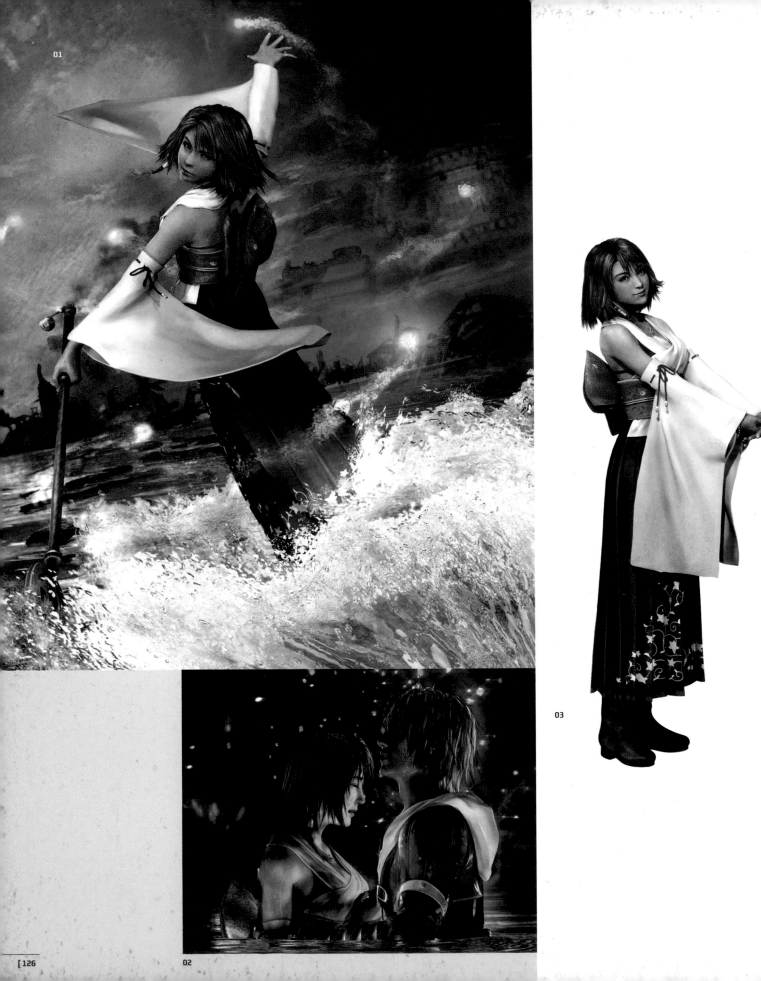

02

03

Our strongest cinematic experiences are when we identify with characters, and these digital icons allow us to be in their skin. This projection onto the persona of an archeologically fixated action heroine, or a stealthy government agent, for example, is not far from what we have been doing in cinema for years. But the digitization of media has given us more freedom to watch and also exhibit agency—or control—over them, meaning that we invest more emotional energy into these characters.

It is arguably more engaging aiding a vibrating rabbit called Vibri across a mutating musical landscape than watching a singing teapot in a Disney film. The anthropomorphism promoted by mainstream animation powerhouses is still evident in these playable and non-playable avatars, but there are more possibilities in exploring Mario's world than there is in *Finding Nemo* (2003). The unfolding digital landscape offers more possibilities for the freedom of digital icons.
>>>

04

IMAGES

]01-03 [*Final Fantasy X: the super-deformed character style of this franchise has evolved with later releases into more realistic, sassy visualizations*
]04 [*Vib Ribbon: Vibri is an engaging avatar despite being limited to 2D vector graphics*

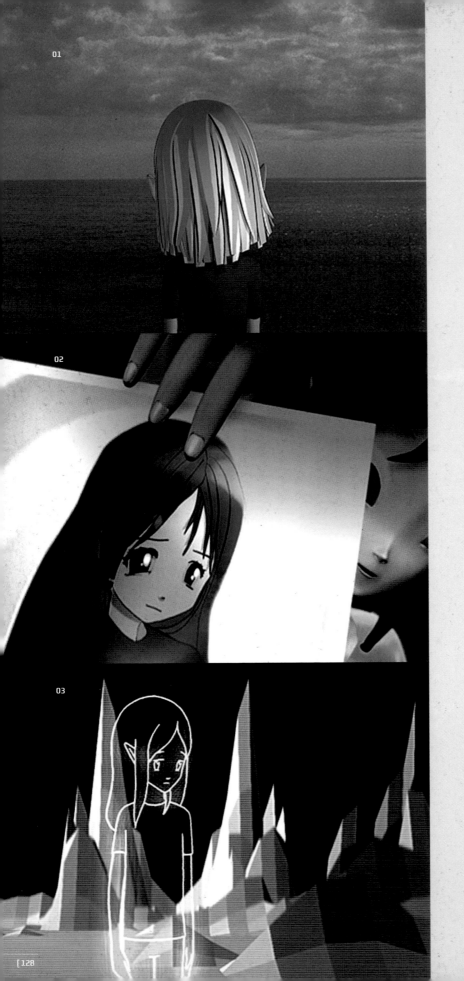

01

02

03

The French artists Pierre Huyghe and Philippe Parreno bought a stock character, Annlee, from Japanese company, Kworks, for exactly this purpose. The artists contacted Kworks as it specializes in creating characters to populate cartoons, comic strips, advertisements, and video games for the Japanese manga (printed cartoons) industry. They wanted a deliberately vague and underdeveloped character, one that wasn't being primed to be a "star," and so managed to purchase her for the relatively small amount of 46,000 yen (less than $500).

With a group of invited artists, they created a series of animations in which Annlee explored different personae, before finally giving her the legal right to her own character. The project, entitled *No Ghost in the Shell* (2002), elicits interesting questions about nascent digital life, and the way not only virtual, but also real, actors are being commodified and their appearances sold as five-inch character representations.

Square's latest animated film, *Flight of the Osiris* (2003), part of the *Animatrix* series, offers the best glimpse into the future of digital icons. The painstaking hyperreal recreation of a swordfight is seductive in its intricate recreation of the curves of the human body, the movement of limbs and faces. The virtuoso nature of its imitation offers up a promise. Ultimately, it is another manifestation of the continuing human quest for eternal youth. If the digital world has to steal our identity to do so, for many, it is a price worth paying.

04

05

IMAGES

] 01-03 [*No Ghost in the Shell: Annlee, an anime character reclaimed from obscurity for artistic experimentation*
] 04-05 [*Soul Calibur II: Heihachi exists in stasis, ageless and indestructable*
] **OVERLEAF** [*Star Wars Galaxies An Empire Divided: the avatars in this game of the epic George Lucas trilogy allow the movie fan to "control" their favorite characters*

RELIVING HISTORY

FILM: THE MATRIX RELOADED
VIDEO GAME: ENTER THE MATRIX
DIRECTORS: THE WACHOWSKI
BROTHERS
YEAR: 2003

As part of the filming process in *The Matrix Reloaded* (2003), the visual effects team had to fully transform certain members of the cast into avatars for some scenes. This enabled them to create effects that progress further than the "bullet time" created in the first movie—the slowing down of time while being able to move freely within the space—to achieve highly visceral virtual camera sweeps around the set, most spectacularly when Neo fights an army of Agent Smith clones in a scene entitled the "Burly Brawl".

Going even further with this emulation, Niobe, Jada Pinkett-Smith's character, was completely digitized and fed through into one of two playable game characters in the complementary computer game, *Enter the Matrix* (2003). The linking between the avatar and the "real" representation of the character is made explicit with the additional footage directed specifically for the game by the Wachowski Brothers on the film set, to bind their fantasy world representations together. This link between "real" filmed and digital space illustrates the enhanced dramatic possibilities being shaped by the growing fluidity between the two.

There is something more honest and genuine about these avatars than many of the manufactured personalities that contemporary society churns out in an effort to sell more product rather than create better entertainment. It is something with which Hollywood hasn't much history of critical engagement, treating it in the most cursory of ways, whether in relation to reality TV with *The Truman Show* (Peter Weir, 1998) and *EdTV* (Ron Howard, 1999), or actual avatars in *S1m0ne* (Andrew Niccol, 2002). In this context, and in an era of "spin," it is not surprising that individuals are developing strategies to bypass this increasingly uncritical mediascape. They are short-circuiting conventional expectations of what particular entertainment formats have been appointed to deliver.

Modders are at the forefront of this. Modding—an activity based on modifying the official and sanctioned environment of a computer game—started as a method of extending the life and possibilities of the game. Most straightforwardly, it is a contest to see who can create the purest or most inventive gaming arena. But extreme modifications of gaming engines, such as those of *Half-Life* (1998), *Quake* (1996), and *Unreal Tournament* (1999), can result in staggeringly different worlds. As the scene matures, more of these modders are subverting the idea of these first-person shooting games as action-based, object-oriented, fantasy killzones.

That a computer game can be an arena of contemplation, of insight, and empathic drama, signals that this medium has become universally valuable as a narrative device over and above its value as entertainment. What happens when an avatar is not a fictional character, not even a celebrity, but a real person whose actions you explore at first hand? I'm convinced, having been critically engaged in both these areas for many years, that computer gaming is now coming into its own. It is rich in phenomenal potential, a prospective route to greater understanding, compassion, and kindness. In exploring real events, computer games are finally going beyond the ability to play battles and create historical re-enactments in wargames, and relate more to the areas of subjective documentary and to biopic.
>>>

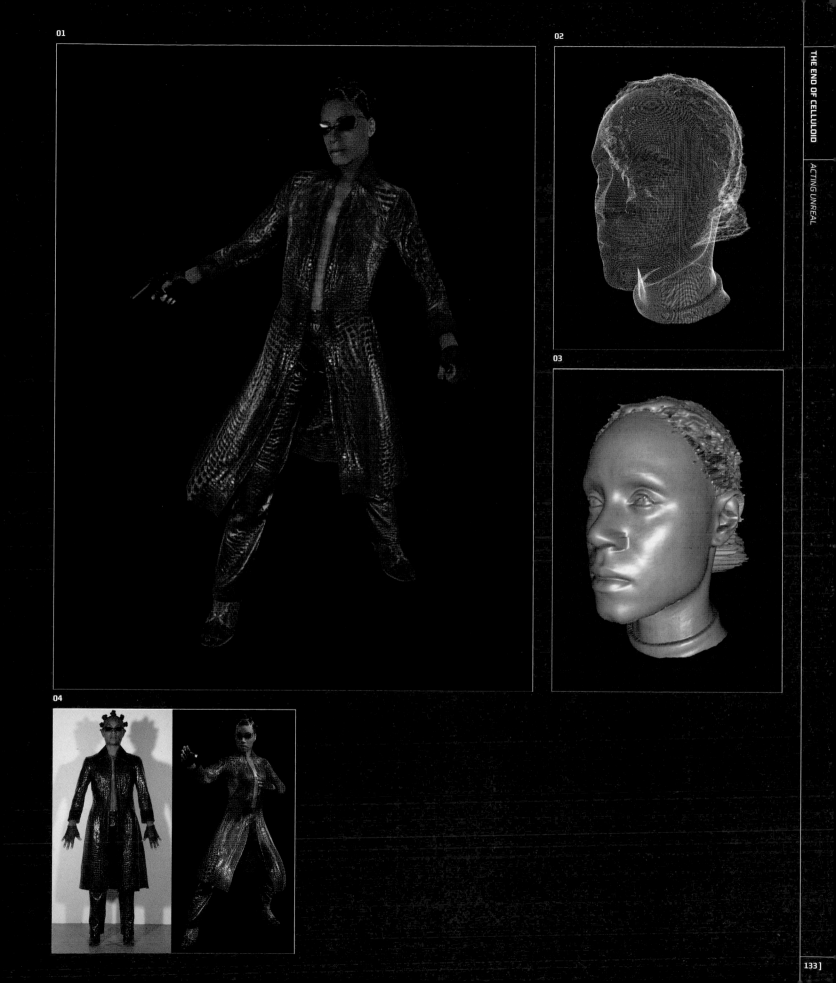

04

05

06

**VIDEO GAME: 9-11 SURVIVOR
MODDERS: JOHN BRENNAN,
MIKE CALOUD, JEFF COLE
YEAR: 2003**

As there has been no commercial imperative to go into this area of computer gaming, it has been left to the modders to innovate and develop. Mods such as *9-11 Survivor* (2003), and standalone games such as Endgames' first chapter *Waco Resurrection* (2003) [i] create complex layers of fact and fiction. *9-11 Survivor* pitches the user into the Twin Towers on the fateful day of their collapse. Endgames is a 3D multiplayer game "based on alternative utopias and apocalyptic moments."

The *9-11 Survivor* modders—John Brennan, Mike Caloud, and Jeff Cole—created the project in response to their own need to come to some understanding of the events of that day.

"This mod evolved as a provocation of our own relationship to the distant events of of 9-11," explain the group. "It was designed to be an investigation. A combination of hollow image and zealous media was our only connection to the event, and through this mediation, we gained no real empathy or insight. So, in a way, this project started out as an attempt to see if this virtual space could be made to fill the gap."

It's clear that traditional media fails to communicate to a large swathe of a generation brought up with multiple-media platforms, so they have developed different behaviors to cope with this excess mediafeed. *9-11 Survivor* places the player as victim, central to the scenario, rather than an adjunct, a number, a falling figure caught by camcorder as part of the spectacle on evening news.

Brennan continues: "In the pursuit of improved renderings and countless buzzwords, the entertainment publishers have refined the visual model of the game world. The side effect of this mindset, however, is that what is produced inevitably explores very little of the utility of these spaces. Why should we limit ourselves based on the whims of good or bad game design? We mod because we feel that this is our medium, and we are confident that it has the capacity to engage material such as 9-11. We didn't grow up with paintbrushes in our hands, but with game controllers and mice."

The inevitable controversy that this type of mod elicits is based on the outmoded idea that this medium is "just for playing games." It is easy to draw comparisons to the criticism evoked by feature films when they challenged novels as the dominant artistic form. But the way this medium can personalize the unfolding drama—rather than reducing it to the spectacle of rolling news reruns of passenger jets hitting the World Trade Center time and time again—is to be commended. It is a way for this generation to reclaim the power of the moving image to provoke and inform as much as it can divert and entertain.

"There is no assertion or triumph for the victim role in our mod; instead we're presenting the scenario of the 9/11 victim in a truthful way. We are demonstrating their hopeless scenario, just as it was," justifies Brennan. For an older generation, this may be too much to take, but it is a valid alternative to the TV movies and Hollywood biopics that usually relate these dramas. "The mod serves as a gateway, a means of inquiry into the event. Gaming, as a subset of simulation (which by necessity is reductionist and condensing), lacks the authenticity of television and film (especially documentaries), but you gain a new set of tools for creating and disseminating these expressions."

A viewer's identification with a character on screen can be intense, lost in a narrative flow; very different to the relationship and direct feedback loop between avatar and player. It offers an extension and an intense "playing out" of the situation. Being presented with the scenario in *9-11 Survivor* that your exit to the ground is blocked, and you are left with the choice of dying in the flames or jumping from the tower is very different to being told in documentary voiceover that these were the choices.
>>>

IMAGES

]01-06 [*9-11 Survivor: a modified Quake gaming engine is used to explore the horrific implications of the World Trade Center tragedy*

In *Waco Resurrection*, the player inhabits the avatar of David Koresh, being bombarded by destabilizing U.S. government "psy-ops" activities, while surrounded in a compound. This can offer insight into why the event ended in disaster as opposed to being defused.

Grahame Weinbren highlights the role of the avatar in presenting the user or viewer with the promise of mastery over a mediascape that is flooding contemporary individuals to such an extent that we are floundering to derive meaning from it [ii]. He cites Slavoj Zizek's explanation of avatars presenting the idea of more control for the individual, or the illusion of more control, over their destiny [iii].
>>>

IMAGES

]01-07 [*Waco Resurrection: bringing a new perspective on historic disasters and apocalyptic events—experiencing, through the David Koresh avatar, the feeling of entrapment and invasion inflicted by the U.S. government creates complex emotional responses*

VIDEO GAME: ICO
DIRECTOR: FUMITO UEDA
YEAR: 2002

This goes some way to explaining the increasing presence of avatars, their changing behavioral possibilities, and their progressively more intimate relationship with us, or at least the characters we identify and empathize with. It is a long way from the world of *The Sims* (2000), where the most popular initial tactic for a time was to devise the most inventive death for one's character.

In the highly imaginative video game, *Ico* (Fumito Ueda, 2002), the player controls a 12-year-old boy who has been banished from his village due to a curse that means he was born with horns. Ico sets up a widespread gaming convention of needing to escape from an imposing fortress ruin. What elevates the game's emotional complexity is the presence of Yorda, the ghost of a young girl, who is consumed by loneliness. The aid and protection Ico must give Yorda, leading her out of the ruins, adds immeasurably to the emotion and enveloping pathos of the action. Due to the detailed attention to atmosphere, lighting, sound, and camera positioning, the game is cinematic.

This breadth of emotion is more easily conveyed by real actors, and that's no doubt why other computer games—such as *Enter the Matrix*—are extending actor performances into the game. Other recent video games such as the game adaptation of *Lord of the Rings: The Two Towers* (2002), take this further by having the actors segue between their real "filmed" selves and their digitally derived avatars, bonding our identification of these selves tighter together.

This transformation in values and attributes isn't a one-way street. As we have become familiar with being in the skin of these avatars, we've become used to the control that it is possible to exhibit over the environment. Feature films have assimilated the augmented senses and powers of these characters.

The original supra-physical action of Hong Kong action films, and the Chinese ghost genres, which first influenced the enhanced and exaggerated physics of computer games, has been reflected and concentrated back on Hollywood. Countless films would not have appeared in the form they have, or even existed without this influence. Films such as *Crouching Tiger, Hidden Dragon* (Ang Lee, 2000), *The Fast and the Furious* (Rob Cohen, 2001), *Pitch Black* (David Twohy, 2000), and, of course, *The Matrix*, are the tip of the iceberg. Especially in something like the masterful millennial thriller, *Strange Days* (Kathryn Bigelow, 1995), we see the influence of the first-person shooter, with the enduring point-of-view shot, and the idea of the avatar revitalizing cinematic space.

From the developing commentaries of event-simulating mods that act as memento mori to the enhanced identification with these avatar/actors, these developments are the ultimate ripostes that the digital development of artistic forms are reductionist, or less concerned with expression than spectacle. Avatars can teach us a lot about our souls.

IMAGES

]01-02[*Ico: in this game, the avatars are imbued with a vulnerability and emotional fragility that strengthens the appeal and subtlety of the gaming experience*

SOURCES

[i] *waco.c-level.cc*
[ii] *"Mastery (Sonic C'est Moi)," Grahame Weinbren in New Screen Media: Cinema/Art/Narrative, Ed. Martin Rieser, Andrea Zapp (2002)*
[iii] *Cyperspace, or the Unbearable Closure of Being, The Plague of Fantasies, Slavoj Zizek (1997)*

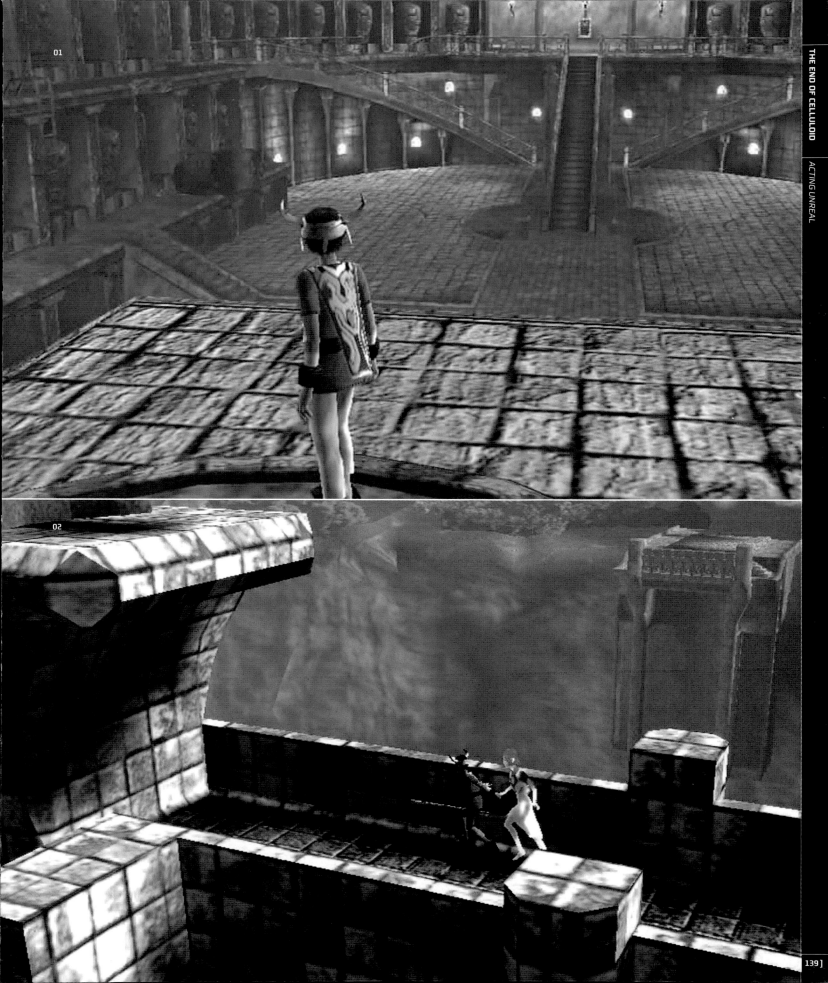

DOUBLE VISION
FILMMAKING FOR FUN AND PROFIT

The End of Celluloid is about the end of a frame with definite boundaries; a narrative with an explicit end, and of entertainment whose only value is in telling a story. Every story should have a destiny, according to semiologist-turned-novelist, Umberto Eco. But what if the narrative is about more than fact or fiction, but also lifestyle and product? The lines between filmmaking for fun and profit are becoming increasingly blurred.

Filmmaking has always had its commercial and artistic sides. In spite of what many say about Hollywood, the two can coexist quite nicely together. With the mass advertising models breaking down for the global brands who need to get their message out there, it is becoming ever more important to be associated with the most striking entertainment. With time-shifting content for viewers becoming the norm, with the increasing take-up of VOD (video on demand), PVRs, and home entertainment servers, commercial advertising as it exists at the moment is being severely undermined. Commercial breaks become redundant, and so must the lines between entertainment programming, commercials, and infomercials.

Product placement, advertiser-funded programming (AFP), and sponsored filmmaking may be hyped niches at the moment, but they present an underdeveloped commercial opportunity for brands with vision, and an artistic opportunity for filmmakers to create highly distinctive and original content that these brands wish to be associated with. The breakdown of broadcasting models and Hollywood's grip on distribution may usher in a—whisper it— coruscating variety of cinematic invention, its primary purpose to astonish and gain attention for itself, not to blandly appeal to the widest demographic, or to follow a formula for a somnambulating primetime. Get ready for a kaleidoscopic array of daring, adventurous moving image. Or is this a vision too far?

In this scenario, it makes total sense that the future for brands isn't just about product placement. It's all very well placing the latest car model in a Bond movie, but when the next instalment has a totally different model and make, the longer-term benefits of brand association fall apart. Ford's ongoing involvement with the television series 24, starring Kiefer Sutherland, shows how going beyond this passive role can really work. By integrating their product in and around the show it becomes less placement and more support. Korean consumer electronics manufacturer Samsung has catapulted in brand value by concentrating promotion around the "Year of The Matrix'" in 2003.

02

03

04

INITIATIVE: THE HIRE
FILMS: BEAT THE DEVIL,
HOSTAGE, THE TICKER
DIRECTORS: TONY SCOTT,
JOHN WOO, JOE CARNAHAN
YEARS: 2001-2002

Active involvement through AFP has been most strikingly successful for BMW. The BMW films in initiative *The Hire* (2001-2002) saw it invest heavily in standalone blockbuster micro-movies. By investing in highly sought-after creative talent to tightly integrate their latest models into mini-features, BMW created a massively successful online viral campaign.

By the second iteration of the series, it had involved directors such as Tony Scott, John Woo, Wong Kar-Wai, Joe Carnahan, and Ang Lee. These films, consisting of standalone capsule narratives but commonly featuring British actor Clive Owen driving a BMW, illustrate the unique properties for brands that invest in creativity outside the bounds of traditional advertising.

The films go far beyond being extended advertisements. The directors involved in the shorts reinforce the possibilities of this space, where highly stylized visuals are viewed as premium. They are able to indulge and heighten their particular sensibilities and their artistic trademarks.

While these shorts all offer condensed narrative scenarios, they work best as mood pieces. In these micro-movies, narrative is distilled to such an extent that it can almost disappear. In so doing, what may previously have been perceived as experimental cinema is drawn into the mainstream. Brands long to create emotive responses, and by abstracting cinema to essences of action and feeling, they are able to do so.
>>>

IMAGES

[01-04 & SEQUENCE OVERLEAF] *The Hire: high-impact, web-distributed short films by award-winning directors— viable as standalone moving image projects as well as highly successful viral marketing for BMW*

Lucky Star (2002), by BMW's automotive competitor Mercedes Benz, also allied itself to a cinematic strategy. Conceived as a mysterious teaser campaign, emulating a hip Hollywood feature trailer, it was produced starring Benicio Del Toro. But this was a teaser without any mainstream payoff. With a big, multiplatform splash on TV, cinema, and online, it was quickly discontinued after the initial press impact.

Lucky Star had a strategy and conception planned with a more traditional advertising agency mindset. It delivered in terms of exposure for traditional advertising, but it was locked from transferring to a more collective, stratospheric impact. The product promised more but didn't deliver. For a split-second, there was talk of it being a film. It should have been. Mercedes should have helped finance it. As an episodic online film, it would have over-fulfilled its potential.

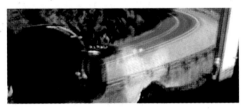

01

02

03

04

05

FILM: SALARYMAN 6
DIRECTOR: JAKE KNIGHT
YEAR: 2002

The push capability of TiVo-style software to deliver this type of content direct to the hard drive of a receptive viewer's PVR suggests a future where a multitude of opportunities exist for brands to make this emotional connection with consumers.

The differences between these two automotive manufacturers' campaigns highlight the differences in strategy for a micro-movie to sell a vision and deliver as an enjoyable entertainment experience to a consumer. Micro-movies need to be free to propagate and have a life of their own. The more control a brand exerts once the content has been released, the less impact it will have. Micro-movies need to be free, distinctive, and hermetic. They should turn into the property of the watcher, not of the brand.

Panasonic's short film series *Digital Networking* (2003) misfires similarly because of the clumsy integration of their solid-state SD memory card as the main subject of the film. The brand makes the cardinal error of being too predictable and too product-centric. The product should never be the protagonist. It should be a facilitator in a micro-movie; a driver for the story, but not the whole story. All the right elements seem to be there, with a promising premise of each film following a data file stored on the SD card, but they do not gel cohesively. Each director—Mark Pellington, Jake Knight, and Hideyuki Tanaka—are innovative filmmakers, but they are not given enough freedom for the films to breathe, and the result falls between camps to reluctantly become ineffective advertising.

Jake Knight, for example, creates *Tape*, a poor imitation of his award-winning *Salaryman 6* (2002), creatively hamstrung by the need for the action to be artificially centered around the memory card. *Salaryman 6*, in contrast to this, was commissioned to allow Knight full creative freedom, with the caveat to explore specific digital compositing techniques.
>>>

IMAGES

]01-05[*Salaryman 6: the award-winning film by Jake Knight was poorly imitated, with too fixed a view on product placement, for Panasonic's Digital Networking*

02

The blipverts used to promote Radiohead's album *Kid A* (2000) are a perfect example of this entertainment. This random collection of blips served instead of the usual music videos to promote the album. Released over the Internet, they were quickly searched out, downloaded, and traded by fans, fulfilling their purpose as cultural memes (or viruses) spreading the desired message.

Created by Chris Bran, Shynola, and Stanley Donwood, they deliver an enigmatic collection of bizarre animations. By communicating a perverse and disturbing world of DNA stick men, mutated bears, and freakish terrains, they create a unique, temporal entertainment space for the world of *Kid A* away from the high noise and high turnover of traditional media. As anti-promos (because the band are anti-commercial, rejecting hard-sell marketing approaches), one couldn't create a more "on message" approach for communicating to Radiohead's audience.

The BOB channel has announced that it will join together the network broadcasting model with the rise of the micro-movie by programming a U.S. television station consisting of films under eight minutes long. These "brief original broadcasts" are to exist in a commercial break-free environment, as what they term "BrandClips"—brand-backed micro-movies—will be used to generate advertising income. At the time of writing, the channel is yet to be launched, and as a clearing house and micro-movie archive, the idea might work. But I think the channel is missing the point; it is still stuck in old media thinking. Nanotainment is a delivery mechanism for ideas and for personal communication, not for high screen averages and television schedules. It works best in a one-to-one conversation with the viewer, not as an always-on transmission.

03

**FILM: FINISTERRE
DIRECTORS: KIERON EVANS,
PAUL KELLY
YEAR: 2003**

04

Music promotion is a fertile ground for visual invention and experimenting with formats. In many respects, the music industry needs to innovate to survive, as its business model is under attack. It is only natural that the creative spaces these music groups occupy should venture into multimedia environments.

Finisterre is an art film dressed up as a document of the preoccupations of a pop group. A collaboration between music video director Kieron Evans and filmmaker Paul Kelly for the band St. Etienne, it creates a much more valid creative impact than a run-of-the-mill pop documentary. Billed as "a psycho-geographic trip through London to the end of the world," *Finisterre* constructs a standalone creative document while elaborating on the band's image, consolidating and refreshing their appeal.

Evans elucidates "I think the main reason why our film works is that the subject of the film exists outside of the band's 'story' and perversely, because of this, the film has actually helped promote the band in new ways. In a broader context, there are very few films that have their own life outside promoting an artists work. The only film in recent years to have achieved this, I'd say, would be Grant Gee's *Meeting People is Easy*."

As a hybrid of promotional video and documentary film, *Finisterre* successfully combines image building with investigation. The double vision of digital media means that as offbeat experimental documentaries are squeezed out of the rigid formatting and audience-chasing imperatives of TV, they can reinvent themselves, discovering a larger audience in a platform-independent space, by piggybacking another pop cultural form.
>>>

IMAGES

]01-02 [*Kid A Blipverts: strengthening an enigmatic message*
]03-04 [*Finisterre: a psycho-geographic trip through
a mysterious and lovingly filmed London as pop
documentary meets art film*

CONCERT VIDEO: INTERSTELLA
5555: THE 5TORY OF THE 5ECRET
5TAR 5Y5TEM
DIRECTOR: KAZUHISA TAKENOUCHI
YEAR: 2003

To compete successfully and have any meaning in this cultural space, it is more important than ever that products—whether these are electronic goods or music groups—assemble a narrative around themselves, whether this is fact or fiction. Digital media oscillates frantically between destroying context and craving more of it.

Interstella 5555: the 5tory of the 5ecret 5tar 5ystem bolsters the fantasy world inhabited by electronic music act Daft Punk. This group insists on not having their faces photographed and invariably turning up for photo-shoots dressed as robots, and *Interstella 5555* functions as a continuation of their refusal to be personally objectified, while being more than a simple concert film. Directed by Kazuhisa Takenouchi, under the visual direction of Japanese animation maestro Leiji Matsumoto, the film is a sublime and colorful anime musical, while containing a sardonic critique of the music industry.

In purely commercial terms, a product can "add value" to the creation of moving image by alleviating it from the commercial strictures of traditional forms. Paradoxically, some of the most successful examples of this are when the film becomes a subversive consumer commentary that acts as an effective selling device.

IMAGES

]01-03 [*Interstella 5555: a retro-styled animated masterpiece of nostalgia that taps successfully into Daft Punk's audience*
]04-06 [*Future of Gaming: a short film that does not treat its product benefactor, PlayStation 2, with kid gloves, thus working much more effectively for both parties*

**SHORT: FUTURE OF GAMING
DIRECTOR: JOHNNY HARDSTAFF
YEAR: 2001**

In the UK, PlayStation 2 commissioned the creation of *Future of Gaming* (2001), a short film directed by Johnny Hardstaff, that illustrates this point. Exploring a retro-futurist world of hi-tech invasion and cultural conflict, it evokes a miniature scenario of dark cold war paranoia, implicating globalization and technological advances in the descent of civilization. Too subversive to be officially endorsed, Sony adopted a *laissez faire* approach and it has gone on to become a cult screening favorite, acting as perfect promotion for the console's seditious image. A world with double vision means we have to get used to living with these paradoxes and use them to our own creative ends.

AGAINST THE GRAIN:
BEYOND VIDEO ART—FILM AS FINE ART

Apart from the giants of the medium— Bill Viola, Bruce Nauman, Nam June Paik—I've always had a healthy disregard for video art: it too often talks its own self-reflexive language to a coterie of art world converts. But the digital age has imbued video art with a new relevance, by allowing experimental forms and techniques to cross-breed and become infused by more commercial, narrative-based genres.

*"The cathode ray tube
will replace the canvas"*

NAM JUNE PAIK, 1965

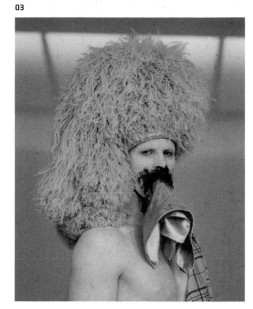

At the forefront of this newly relevant engagement between the cinema and the art world is U.S. artist Matthew Barney, lately hailed as "the most important artist of his generation" by *The New York Times*. *The Cremaster Cycle*, a series of five films made between 1995 and 2002, has propelled Barney into the stratosphere of art stars. In 2003 he became the youngest artist to present a solo show at the Guggenheim Museum, New York, his reputation being made due to this epic project. With the films at its core, the project also comprises drawings, photographs, and sculptures, all loosely based on the jumping-off point of male sexuality. Barney himself has likened his cycle to a "narrative sculpture."
>>>

**FILM: THE CREMASTER CYCLE
DIRECTOR: MATTHEW BARNEY
YEARS: 1995–2002**

The ability to infinitely manipulate moving image has become alchemical: it can do more than transmute pixels into polemic for these artists. Fine art that can be fused with popular culture is more engaging to viewers who would never usually come into contact with this work if it were confined to a gallery. Contemporary works, ranging from the epic to the intimate, are giving experimental cinema a renewed bearing.

IMAGES

]01-03 [*The Cremaster Cycle: Barney's art film mythology is filled with enigmatic imagery*

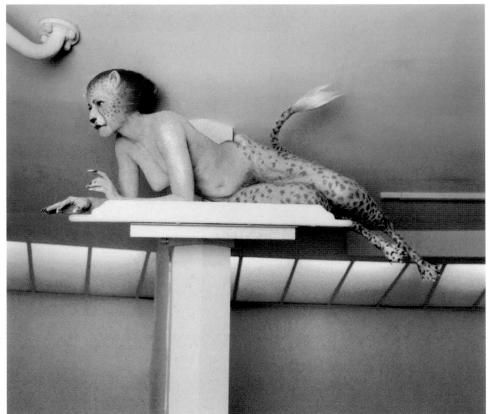

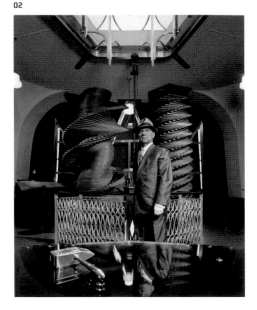

This collision of Celtic and ancient symbolism with the visual expressions of digital entertainment goes against the grain of most "art films"—it works on a highly visceral level, exploding with a dazzling array of vibrant imagery and striking locations. The work is an unfolded film, a puzzle that cannot be completed.

The segregated imagery and enforced isolation of moving image art is magnificently uncaged in the supra-narrative free-for-all of Barney's work. The artist has created a dream/nightmare world populated by convicted killers, horned beasts, bunny-girl chorus lines, androgynous faeries, water sprites, hardcore bands, blimp stewardesses, and Vaseline-melting sculptors. It is an astonishingly varied and surreal series of conflated fables and loaded imagery. Barney himself makes central appearances in his films as the murderer Gary Gilmore, a satyr, a magician, and, in the case of *The Order* (the grand finale of *Cremaster 3*, and the first of his work to be published for general release on DVD), a caber-tossing Masonic apprentice. The films' grand cycle of creation and destruction mirrors the rise and fall of the cremaster muscle—used to raise and lower the testicles.

The Cremaster Cycle is an evolutionary adventure; it is, variously, a "gothic Western," 1930s musical, opera, thriller, sports broadcast, and horror film. "What had been a kind of broadcast-sports vessel became a cinematic-genre vessel" [i], Barney has said in explaining the evolution of the films.

The Order is an encapsulation of the cycle's odyssey of reclamation and transformation of self. Barney's protagonist, the Entered Apprentice, must pass through the Masonic degrees, as he ascends the Slope of Hiram (the Guggenheim's famous spiral walkway), reflecting the "level completes," the spatial discovery and conquest, of video games. Witness the way the "Level Bosses" and the Entered Apprentice rotate on the plinth at the beginning of the sequence—game start— selected like video game characters.

"It doesn't carry narrative as much as it attempts to create presence, in the sculptural sense of the word. As a viewer myself, things like that excite me very much," adds Barney.

In a world where monuments are being destroyed, Barney's monumentalist work could be viewed as an anachronistic anomaly. By constructing such an immense moving image epic, he has created the first great film of the digital age to bridge the void between video art and cinema. It is the epitome of the "new and heightened bricolage: metabooks which cannibalize other books, metatexts which collate bits of other texts," described by philosopher Fredric Jameson in his explanation of "the new art of experimental video." [iii]
>>>

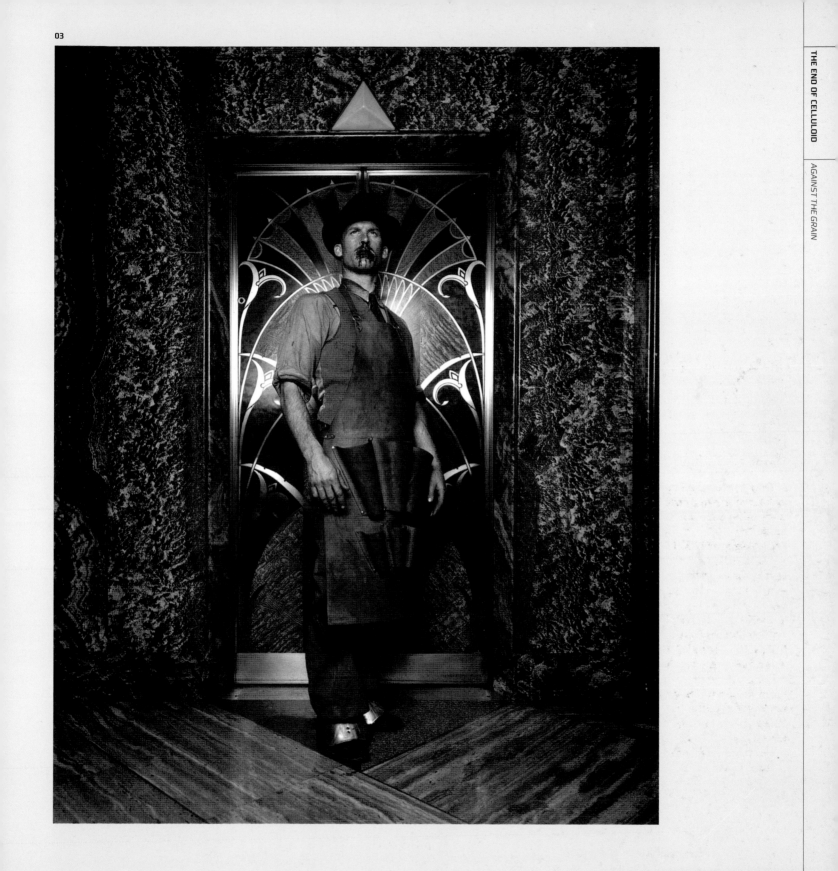

IMAGES

]01-03[*The Cremaster Cycle: symbolism is used playfully and wilfully by Barney throughout the series*

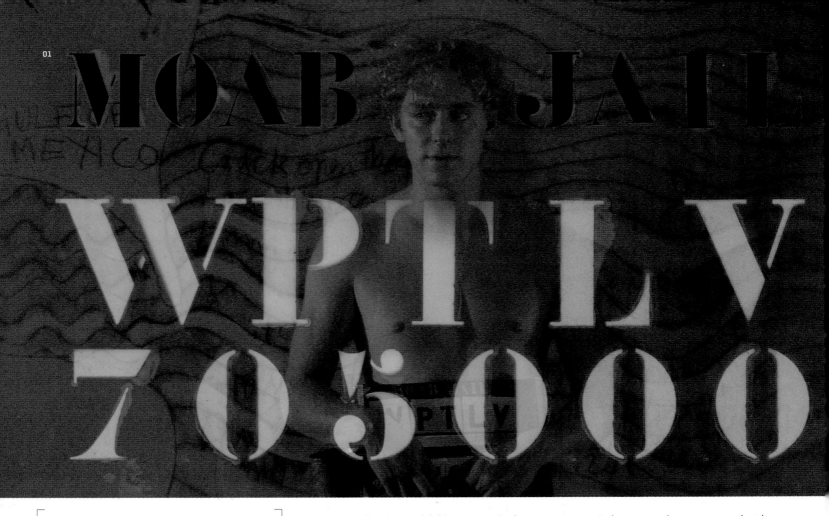

**FILM: THE TULSE LUPER SUITCASES
DIRECTOR: PETER GREENAWAY
YEAR: 2003–**

While Barney disorients with bizarre mystical and sexual imagery, the British experimental filmmaker Peter Greenaway does so with information. Throughout his career, he has cataloged, indexed, filed, and classified. The filmmaker's whole oeuvre is obsessed with taxonomic breakdowns. If Barney processes information in the blurred composites of computer gaming, then Greenaway "Googles" it. No surprise, then, that he has said he has to limit himself to a few hours a week of Internet use, otherwise he's sucked hopelessly into the massive databasing and information chronicling of the medium.

Greenaway's long gestating current project is *The Tulse Luper Suitcases*. Over three years, this massive multimedia project will produce a myriad of artifacts; it is to encompass three films, a television series, 92 DVDs, and an online archive, altogether making up an encyclopedic history of Greenaway's sometime alter ego, Tulse Luper.

"Creation, to me, is to try to orchestrate the Universe to understand what surrounds us. Even if, to accomplish that, we use all sorts of strategems which in the end prove completely incapable of staving off chaos," says Greenaway. [iii]

This ambitious project reconstructs the personal history and projects of Luper through the evidence encountered in the 92 suitcases. This is the nearest anyone has yet come, creating a totally alternative history, as outlined by the novelist Jorge Luis Borges in *Tlön, Uqbar, Orbis Tertius* [iv], a short story in which a mammoth secret project to create an encyclopedia of a fantasy world comes to absorb and replace the real one.

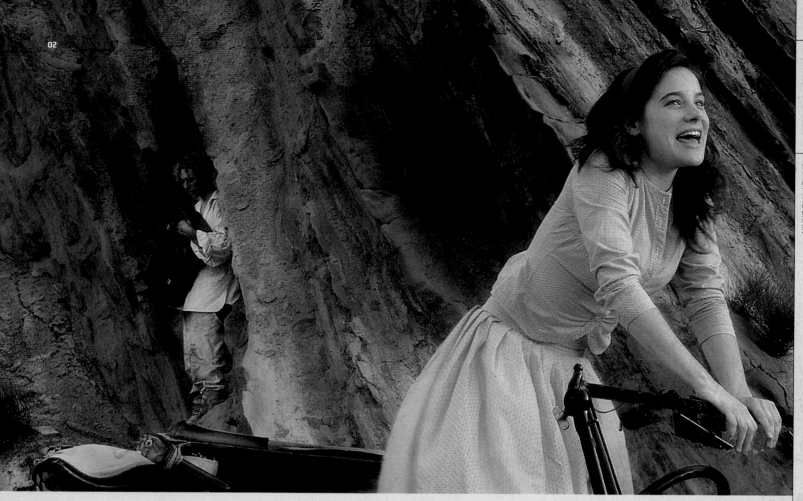

02

Greenaway has been an avid experimenter of moving image, unafraid to use layered imagery, overlaying text and graphics, with increasing complexity and nuance throughout his career. He's utilized these technologies to modify, to "paint" his images, to capture them in high-definition video, almost as soon as the possibilities were available. A film like *Prospero's Books* (1991) illustrates how far ahead of many other filmmakers and artists Greenaway has been in investigating and prophesying the fragmenting of cinema, the feature film's dissolution into digital elements to be accessed and experienced through personal experience.

Greenaway adds: "Cinema is an old technology. We've seen an incredibly moribund cinema in the last 30 years. In a sense, Godard destroyed everything... he broke cinema apart, fragmented it, made it very, self-conscious. Like all the aesthetic movements, it's basically lasted about 100 years."

It appears to me that the only way to save cinema is to make it more individual and more intimate. *The Tulse Luper Suitcases* fulfills this requirement; it is an unfolding film that doesn't give up all its secrets at once. Indeed, it will require an obsessive level of commitment from a follower to discover all the narrative twists and turns and the secluded histories.
>>>

IMAGES

]01-02 & OVERLEAF[*The Tulse Luper Suitcases:*
Greenaway emphasizes the visual, painting with light

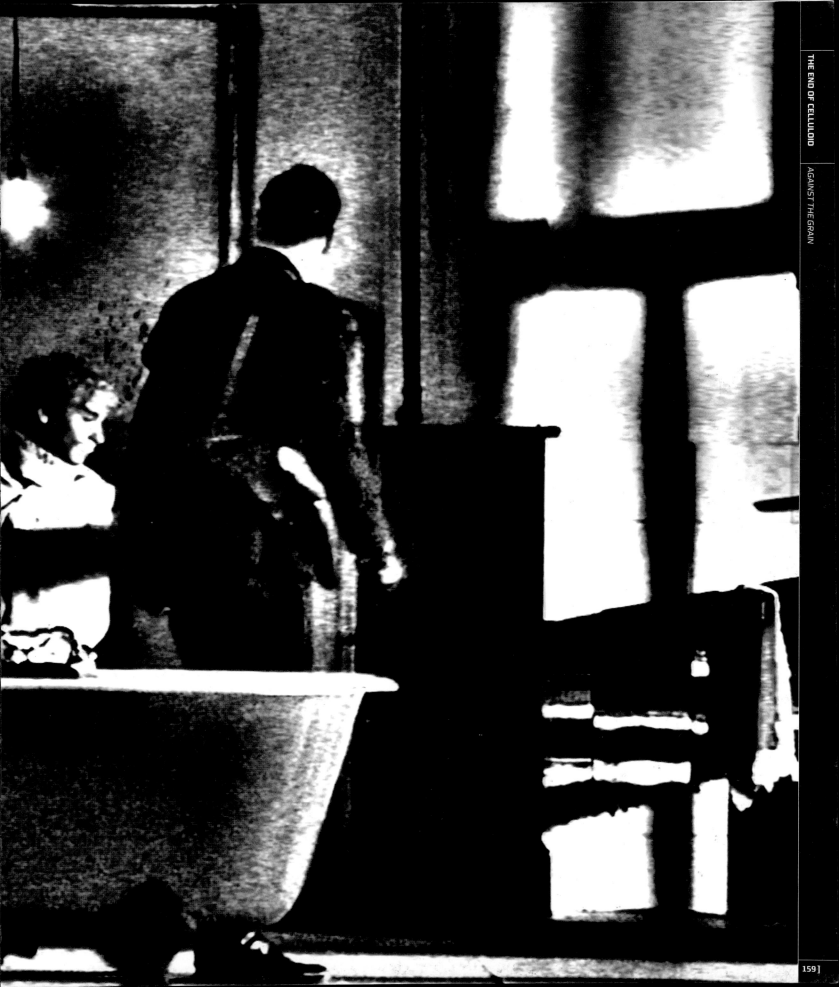

FILMS: THE TELEPHONE CALL,
THE BERLIN FILES
DIRECTOR: JANET CARDIFF
YEARS: 2001-2003

It is a relief to experience a counterpoint to these sprawling meta-works. Janet Cardiff's moving imagemaking points to another approach to capturing this intimate viewing experience. She has described her site-specific work *The Telephone Call* (2001) at MOMA, San Francisco, as a "video walk." The work is an extension of her audio walks. With these, she creates an imaginary soundtrack using binaural recording—which creates ultra-realistic directional sound—guiding the listener along the underground tunnels at the Villa Medici in Rome, or the streets of London's Whitechapel. By donning headphones and holding a camcorder that plays the already recorded journey on its flip-out monitor, the viewer enters a shadow image of the space. Firstly, Cardiff's voice on the soundtrack gives instructions to the viewer-user, to direct the camcorder in the direction that mirrors the image on-screen, and to follow this image around. The camera guides you through the museum space, around corners, up stairs, through galleries, and into stairwells forbidden for the casual gallery-goer to enter. Cardiff says the experience is: "Almost like

02

03

Once assimilated into this hybrid space between the pre-recorded and the present, the people around you feel more like ghosts than the "real" characters on the camcorder screen the soundtrack instructs you to follow. It feels like mining time. This is a moving image experience that is part archeological dig, part thriller.

"One of the things about the media of cinema is its ability to transport you somewhere else, creating that strange separation from the reality you're living in... you're in one layer of reality, overlaid with the physical world," says Cardiff. [vii]

Using the familiar device of the camcorder to transport the viewer into a psychological adventure, Cardiff is pioneering a cinema of motion and of environment. *The Berlin Files* (2003, made in collaboration with George Burés Miller) reduce feature narratives into cinematic sequences which hint at suspense, danger, and loss.

Unusually for filmmaking in the digital age, Cardiff is bringing cinematic experience back into a physical space, rather than further into a virtual one. A new generation of personal video players may soon bring this type of encounter to a wider audience than the lucky few able to make it to the few video-walk locations that Cardiff has created.

What all these moving image works do is place the viewer at the center of things, the user of the experience, able to interact, define, and create their own journeys through the stories. This is the way cinema will survive—by bursting free of the screen.

SOURCES

[i] *Self-Portraiture Meets Mythology, Scott Foundas, Indiewire.com*
[ii] *Postmodernism, or, The Cultural Logic of Late Capitalism, Fredric Jameson (1992)*
[iii] *Collected Fictions, Jorge Luis Borges (1999)*
[iv] *Peter Greenaway interview, salon.com*
[v] *Museum tour: Walk this Way, Jason Spingarn-Koff, Wired.com (3/2001)*
[vi] *Janet Cardiff and George Bures Miller interview, Kate Zamet, kultureflash.net (8/2003)*

IMAGES

] 01-03 [*The Berlin Files: loaded, deliberately ambiguous sequences suggest complex narratives*
] 04 [*The Telephone Call: holding the camcorder transforms the viewer into their own cinematic space*

RETURN OF THE EPIC
CINEMA'S LAST STAND

Filmmaking on an epic scale has returned to cinema, and box office returns achieved indicate that, superficially at least, cinema is in great shape. But the artistic health and vitality of filmmaking cannot be judged by financial returns. The increasing reliance on these box office juggernauts, crushing audience resistance in a wave of blanket marketing techniques to justify the preeminence of the cinematic art form, doesn't auger well for the medium. In fact, it indicates the end of celluloid as we know it.

We thought the days of *Spartacus* (1960), *Zulu* (1964), and *Lawrence of Arabia* (1962), were long gone. But ballooning budgets and blossoming visual effects technology have ostensibly revived the spectacular. Films such as *Titanic* (1997), *Gladiator* (2000), and *Lord of the Rings* (2001-2003), are awe-inspiring visual feasts. Let us also consider *Terminator 3* (2003), the superhero films such as Ang Lee's *Hulk* (2003) or Sam Raimi's *Spider-Man* (2002), putting aside their accomplishments or deficiencies.

Many of these films are simply sold on their ability to up the ante of on-screen mayhem. They are sheep in wolves' clothing, promising entertainment with bite, but delivering not much more than a bleat as they stretch reality and credulity with special effects that overreach themselves. As the death knell tolls for a Hollywood system peddling an endless stream of indistinguishable narrative entertainment, audiences scatter to find inspiration in other amusements. The big screen has become all spark and no fizz.

This may seem paradoxical, in that this book revels in the elastic realities of digital moving image, in the excesses of accelerated cinema, the quick hits of nanotainment, or the slow-burn satisfaction of unfolded films, but these are all alternative visions. They progress moving image beyond the conventional, past the ground of visual excess subsiding under a lack of imagination and new ideas.

If we look back at the history of storytelling and the oral tradition of the bards, narrative models have not changed a great deal. There is a universal need to update and tell the same stories that people want to hear. But these bards reacted to the audience, they kept them guessing, mixed it up; they breathed life into their legends and chronicles. Fundamentally this is something most films have forgotten to do. The process has become hamstrung by the lowest common denominators of international appeal. Universal inoffensiveness has come to mean blandness on a worldwide scale. As the average individual's usage of the Internet rushes past television, itself having long ago eclipsed that of cinema viewing, the obituary for cinema has already been written: strangled to death by the tyranny of the screen test.

In the mid-1990s, the U.S.-based Russian expatriates Komar and Melamid created a conceptual art project that explored this obsession with market research and polls to create the *Most Wanted and Least Wanted* painting project [1]. Using a professional research organization to survey people's aesthetic preferences and tastes in painting in various countries they produced work based on these findings. The results found any differences in the responses were flattened out to, in the case of the U.S., result in a preference for an overwhelmingly kitsch figurative landscape. The *Least Wanted* painting, what was most rejected, was of course a brazen avant-garde design of bold colors and abstract art. The U.S. respondents weren't alone in this, the response was a common one to other countries surveyed.

The goal to reach a mass audience, to please the greatest number of people, has driven cinema as a commercial art form. Looking at this art project, it is easy to see how cinema has lost its way.

02

03

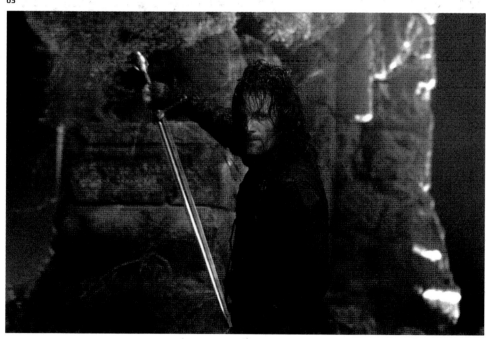

So enjoy the screen spectaculars so huge they can only be contained by trilogies: *The Lord of the Rings*, *The Matrix* trilogy, *X-Men*, and *Star Wars* prequels. Whoop it up at *Alexander the Great* and all the other upcoming historical epics as cinema tries to recapture a long-gone golden age, because these epics are the supernova. They are the exploding stars as cinema goes through its big bang and dissipates into thousands of fragments and forms of moving image.

The big question is: how does cinema regain a sense of purpose? I don't believe it can stop its disintegration, as the pull toward personalized viewing experiences gets stronger as the hardware and software to make this happen becomes more ubiquitous. But it can regain its vitality and sense of purpose by rejecting excess for its own sake. Perhaps it is time for a spell in rehab to detox and get itself together. >>>

IMAGES

]01-03[*The Lord of the Rings: a rare example of performances and digital effects working together in blockbuster format to create a critically praised trilogy*

FILMS: IDIOTERNES (THE IDIOTS)
DIRECTOR: LARS VON TRIER
YEAR: 1998

01

02

The 1990s saw various reactions against this model of excess and uniformity. Copious amounts were written about the Dogma movement, a cinema code in which the filmmakers signed up to a vow of chastity to strip the artifice away from filmed drama. Lars Von Trier's *Idioternes* (*The Idiots*, 1998), and Thomas Vinterberg's *Festen* (*The Celebration*, 1998), were compelling motion pictures precisely because they were a reaction to the cinematic norm, but the ideological stance was only good as a protest, opposing as it did any real innovation.

At the opposite end of this spectrum, forums for greater experimentation in digital film, such as the *onedotzero* [which the author created] and *Resfest* festivals, appeared. These events champion motion graphics, digital effects and image acquisition to endorse other possibilities for moving image. They act as spaces for the exploded filmmaker, coming from other creative disciplines to influence moving image. By bringing cinema back to its roots, providing platforms for graphic and visual experiments where the narrative is often secondary, they act as a contemporary mirror to early cinematic movements, exploring new styles of visual composition. They break down modern cinema into elements where other digital art forms can be fused to them and tested as filmic hybrids.
>>>

03

Axel, you're not pissing on a council vehicle again ... I'm sorry.

04

You pretend you're idiots.

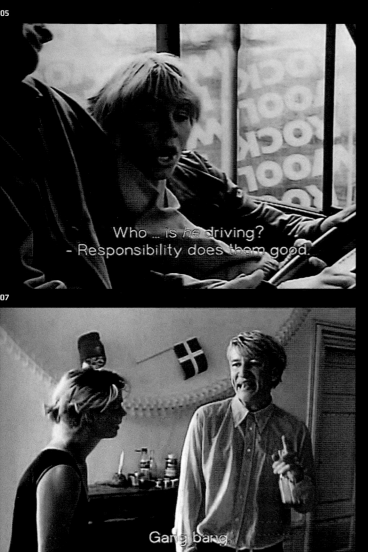

05

06

07

08

09

10

IMAGES

] 01-10 [*Idioternes: stripped down DV filmmaking according to the Dogme manifesto's "vow of chastity"—supposedly unmanipulated filmmaking*

**FILM: LA JETEE
ARTIST: CHRIS MARKER
YEAR: 1962**

These diametrically opposed factions revisit cinema's constituent parts, and ask that we rebuild it from the ground up. By stripping away, we can experience the spectacle unadorned and unadulterated.

La Jetée (Chris Marker, 1962) became a sci-fi classic by using a restrained combination of still shots and voiceover. It employed an asceticism and economy of image to create a stark and epic power on the viewer. Marker has talked of creating "haiku for the eyes."

IMAGES

]01[*La Jetée: Marker's masterpiece of simplicity.
Cinema created by combining a series of still images*
]02[*L'Arrivée du Train: the early Lumiére film (see page 9).*
We must return to the past to reinvent cinema's future

01

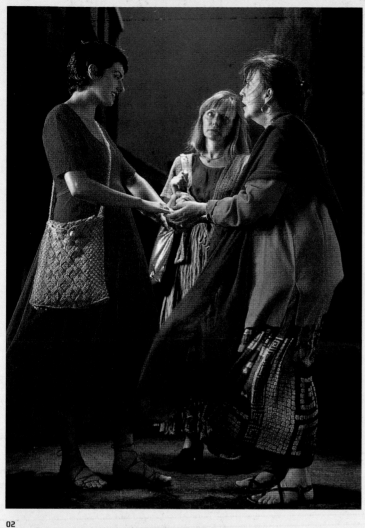

02

VIDEO/SOUND INSTALLATIONS: THE PASSING, THE GREETING, FIVE ANGELS FOR THE MILLENNIUM
ARTIST: BILL VIOLA
YEARS: 1991-2001

The contemporary video works of Bill Viola reduce the use of montage to dwell on the dramatic beauty of scenes and images, such as in *The Passing* (1991) and *The Greeting* (1995). Works such as these, and *Five Angels of the Millennium* (2001), veer between quiet contemplation and sudden bursts of emotional energy—raw, revelational moments.

Viola says: "I discovered the films of Oskar Fischinger and the 'pure cinema' of Hans Richter from the 1920s—patterns of pure light and abstract movement flickering across the screen, like the Kubelkas later, and the video synthesizers after that, and the incredible sophistication and intelligence of the abstract Islamic art of pattern before them all." [ii]

Viola's latest exhibition of work, *The Passions* (2002), revives compositional styles not commonly seen since the time of the Old Masters in painting. They reflect the stylings of Hieronymus Bosch, Pontormo, and Sassetta. In their use of shifting perspectives, simultaneity, and distorted realities, they feel utterly modern. In reducing narrative to emotional essences, they feel absolutely timeless. They show that after being blinded by spectacle, if we look back at the past, we can invent cinema's future in a digital age.

IMAGES

]01[*The Greeting: mirroring a classical scenario, the resonance is heightened by its ultra-slow playback*
]02[*The Passing: Viola's emotional meditation on the loss of his mother*

IMAGE

]01[*Five Angels for the Millennium (Fire Angel):*
a stark, emotional journey through sound and video

SOURCES

[i] *Most Wanted paintings, Komar & Melamid,*
www.diacenter.org/km
[ii] *"History, 10 Years, and The Dreamtime", in Reasons for*
Knocking at an Empty House: Writings 1973–1994, Bill
Viola (1995)

SELECTED FURTHER READING/VIEWING/PLAYING

LINKS TO FURTHER SOURCES CAN BE FOUND AT
www. endofcelluloid.com

MOVING IMAGE:
28 Days Later, Danny Boyle (2002)
400 Anarchists, Grant Gee (2002)
9-11 Survivor, John Brennan, Mike Caloud, Jeff Cole (2003)

Akira, Katsuhiro Ôtomo (1988)
Animatrix, The, Various (2003)
Avalon, Mamoru Oshii (2001)

Blood: The Last Vampire, Hiroyuki Kitakubo (2000)
Bodysong, Simon Pummell (2003)
Buena Vista Social Club, Wim Wenders (1999)

Chungking Express, Wong Kar-Wai (1994)
Cremaster Cycle, The, Matthew Barney (1995–2002)

Darkened Room, David Lynch (2002)
Dumbland, David Lynch (2002)

Endgames, C-Level (2002)
Enter the Matrix, Andy and Larry Wachowski (2003)
Eschaton, Strange Company
Eye for an Eye, An (UNKLE), Shynola and Ruth Lingford (2002)

Festen (Celebration, The), Thomas Vinterberg (1998)
Figures of Speech, Bob Sabiston (2000)
Final Fantasy: The Spirits Within, Hironobu Sakaguchi and Moto Sakakibara (2001)
Finisterre, Kieron Evans and Paul Kelly (2003)
Flex, Chris Cunningham (2000)
Future of Gaming, Johnny Hardstaff (2001)

Ghost in the Shell, Mamoru Oshii (1996)
Grand Theft Auto: Vice City, Rockstar Games (2002)

Hire, The: Ambush, BMW films, John Frankenheimer (2001)
Hire, The: Beat the Devil, BMW films, Tony Scott (2002)
Hire, The: Chosen, BMW films, Ang Lee (2001)
Hire, The: Hostage, BMW films, John Woo (2002)
Hire, The: Powder Keg, BMW films, Alejandro González Iñárritu (2001)
Hire, The: Star, BMW films, Guy Ritchie (2001)
Hire, The: The Follow, BMW films, Wong Kar-Wai (2001)
Hire, The: Ticker, BMW films, Joe Carnahan (2002)
Hotel, Mike Figgis (2001)

Ico, Fumito Ueda (2002)
Idioterne (Idiots, The), Lars von Trier (1998)
In the Mood for Love, Wong Kar-Wai (2000)
Interstella 5555: the 5tory of the 5ecret 5tar 5ystem, Kazuhisa Takenouchi (2003)

Jetée, La, Chris Marker (1962)

Legend of Zelda: The Ocarina of Time, Shigeru Miyamoto (1998)
Legend of Zelda: The Wind Waker, Shigeru Miyamoto (2003)
Lord of the Rings: The Two Towers, Peter Jackson (2002)
Lucky Star, Mercedes Benz, Michael Mann (2002)

Matrix, The, Andy and Larry Wachowski (1999)
Matrix Reloaded, Andy and Larry Wachowski (2003)
Matrix Revolutions, Andy and Larry Wachowski (2003)
Meeting People is Easy, Grant Gee (1999)
Memories, Koji Morimoto and Tensai Okamuro and Katsuhiro Ôtomo (1996)
Metal Gear Solid 2: Sons of Liberty, Hideo Kojima, Konami (2001)
Metal Gear Solid, Hideo Kojima, Konami (1998)
Modulations, Iara Lee (1988)
My Little Eye, Marc Evans (2002)
My Trip to Liberty City, Jim Munroe (2002)

Nantes Triptych, The, Bill Viola (1992)
Natural Born Killers, Oliver Stone (1994)

No Maps for these Territories, Mark Neale (2000)
Noiseman Sound Insect, Koji Morimoto (1997)

Order, The, Matthew Barney (2003)

Panasonic Digital Networking, Jake Knight, Mark Pellington and Hideyuki Tanaka (2003)
Passion, The, Bill Viola (1999)
Passions, The, Bill Viola (2003) (Collected works for exhibition)
Perfect Blue, Satoshi Kon (1997)
Pillow Book, The, Peter Greenaway (1996)

Rabbits, David Lynch (2002)
Radiohead blips, Chris Bran, Shynola (2001)
Radiohead blips, Shynola, Chris Bran and Stanley Donwood (2001)
Rebel Vs. Thug, Ken Thain (2002)
Rez, UGC, Sega (2001)
Ring, The, Gore Verbinski (2002)
Ringu, Hideo Nakata (1998)
Roadhead, Bob Sabiston (1999)
Rules of Attraction, The, Roger Avary (2002)

Shenmue, Yu Suzuki, Sega (1999)
Snack & Drink, Bob Sabiston (1999)
Spirited Away, Hiyao Miyazaki (2001)
Spun, Jonas Åkerlund (2002)
Super Mario 64, Shigeru Miyamoto, Nintendo 1996)

Tekkon Kinkreet (Black & White), Koji Morimoto (1999)
Telephone Call, The, Janet Cardiff (2001)
Tetsuo 2: Body Hammer, Shinya Tsukamoto (1992)
Tetsuo: The Iron Man, Shinya Tsukamoto (1988)
Third Place, The, TBWA, David Lynch (2000?)
Timecode, Mike Figgis (2000)
Tomb Raider, Eidos (1996)
Tulse Luper Suitcases, The, Peter Greenaway (2003)

Vib Ribbon, Masaya Matsuura (2000)

Waking Life, Richard Linklater (2001)

BOOKS & PUBLICATIONS:
Brand New, Jane Pavitt, V&A Publications (2002)

Collected Fictions, Jorge Luis Borges, Penguin (1999)
Creativity: Flow and the Psychology of Discovery and Invention,
Mihalyi Czikszentmiyalhi, HarperCollins (1996)

Dictionary of the Khazars, Milorad Pavic, Vintage Books (1989)

Hamlet on the Holodeck: The Future of Narrative in Cyberspace, Janet H. Murray,
The MIT Press (1997)
Hertzian Tales: Electronic Products, Aesthetic Experience and Critical Design,
Anthony Dunne, Royal College of Art (1999)

Language of New Media, The, Lev Manovich, The MIT Press (2001)

New Screen Media: Cinema/Art/Narrative, Ed. Martin Rieser, Andrea Zapp, BFI (2002)

Plague of Fantasies, The, Slavoj Zizek, Verso (1997)
Postmodernism, or, The Cultural Logic of Late Capitalism,
Fredric Jameson, Verso (1992)

Reasons for Knocking at an Empty House: Writings 1973–1994, Bill Viola,
Thames & Hudson (1995)
Res magazine

Symbolic Exchange and Death, Jean Baudrillard, Sage Publications (1993)
Synaesthesia: The Strangest Thing, John Harrison, Oxford University Press (2001)
Travels in Hyperreality, Umberto Eco, Picador (1987)
Virilio Reader, The, James Der Derian, Blackwell Readers (1998)
Wired magazine

PICTURE CREDITS

Courtesy and/or copyright of:

P14-17 *My Little Eye*, WT2/Momentum Pictures
P18-21 *Ringu*, Omega Inc/ICA Projects/Tartan Video
P22-25 *28 Days Later*, 20th Century Fox
P28-29 *No Maps for these Territories*, Mark Neale
P30-33 *Bodysong*, Hot Property Films/Film Four/Film Council/Pathe Film Distributors
P34-37 *Meeting People is Easy*, Courtyard Management/EMI
P38-39 *A House with Broken Windows* and *400 Anarchists*, Grant Gee
P42-45 *Avalon*, Mamoru Oshii & Avalon Project/Wild Bunch
P46, 50-51 *The Matrix Reloaded*, Warner Bros
P47-49,133 *Enter the Matrix*, Shiny Entertainment/Atari
P46-51 *Animatrix*, Warner Bros
P52-53 *Blood: The Last Vampire*, Production IG/Manga Entertainment
P56,124-125 *Metal Gear Solid 2: Sons of Liberty*, Konami/SCEE
P57-61 *Metal Gear Solid 3: Snake Eater*, Konami
P62-65 *Rebel Vs. Thug*, Ken Thain
P66 *Steelwight*, Strange Company
P67 *Eschaton*, Strange Company
P70 *Timecode*, Red Mullet/Screen Gems/Sony Pictures
P71 *Timecode* scripts, Mike Figgis
P71-73 *Hotel*, Red Mullet/CDA
P74-75 *About Time 2*, Red Mullet/Road Movies
P76 *Rabbits*, David Lynch
P78-79 *Dumbland*, David Lynch
P80-81 *The Third Place*, David Lynch/TBWA/SCEE
P84-87 *The Rules of Attraction*, Lions Gate Entertainment
P88-89 *Windowlicker*, Aphex Twin/Warp Records
P89 *Drukqs*, Aphex Twin/Warp Records
P90-91 *Flex*, Chris Cunningham/Anthony D'Offay Gallery London
P92-95 *Spun*, Newmarket Films/Pathe Film Distributors
P98-101 *Noiseman Sound Insect*, Koji Morimoto/Studio 4°C/Bandai Visual
P102-103 *Tekkon Kinkreet*, Koji Morimoto/Trilogy
P104 *Le Saunda*, Koji Morimoto
P106-107 *Snack & Drink*, Flat Black Films
P107 *Figures of Speech*, Flat Black Films
P108-111 *Waking Life*, Detour Filmproduction/20th Century Fox
P112-113 *An Eye for an Eye*, Shynola/Island
P118-119, 146 *Kid A Blipverts*, Shynola/EMI
P117 *Radiohead TV*, Chris Bran & various/EMI
P120 *My Trip to Liberty City*, Jim Munroe/nomediakings.org
P126 *Final Fantasy X*, Squaresoft/SCE
P127 *Vib Ribbon*, SCE
P128 *No Ghost in the Shell*, Annlee/Huyghe & Parreno
P129 *Soul Calibur II*, Electronic Arts
P130-131 *Star Wars Galaxies: An Empire Divided*, Lucasfilm Entertainment Company Ltd.
P134-135 *9-11 Survivor*, John Brennan, Mike Caloud, Jeff Cole
P136-137 *Endgame Waco Resurrection*, C-Level
P138-139 *Ico*, SCE/SCEE
P142-144 *BMW Films: The Hire*, BMW
P145 *Salaryman 6*, Jake Knight/Eye Candy
P147 *Finisterre*, CC-Lab
P148 *Interstella 5555: the 5tory of the 5ecret 5tar 5y5tem*, Daft Punk/Soda Pictures
P149 *Future of Gaming*, Johnny Hardstaff/ SCE
P152-155 *The Cremaster Cycle*, The Order, Matthew Barney/Palm Pictures
P156-159 *The Tulse Luper Suitcases*, Kasander Films
P160 *The Telephone Call*, Janet Cardiff, 2001, San Francisco Museum of Modern Art, Purchased through the Accessions Committee Fund and a gift of Pam and Dick Kramlich
P161-162 *The Berlin Files*, Janet Cardiff & George Bures Miller, 2003
P164-165 *Lord of the Rings: The Two Towers*, New Line Entertainment/Entertainment Film Distributors/Electronic Arts
P166-167 *Idioternes*, Zentropa
P168 *La Jetée*, Argos Films/Ronald Grant Archive
P168 *L'Arrivée du Train*, Louis & Auguste Lumiere/Ronald Grant Archive
P169 *The Greeting*, Bill Viola, 1995, Video/sound installation. Photo, Kira Perov
P169 *The Passing*, Bill Viola, 1991, In memory of Wynne Lee Viola, Videotape, BW, mono sound. Photo, Kira Perov
P170-171 *Five Angels for the Millenium (Fire Angel)*, Bill Viola, 2001, Video/sound installation. Photo, Kira Perov

FINAL CREDITS

Most of all to Leonie, Harper, and Pasha for their inspiration.

The Rotovision team; particularly Leonie Taylor for her editing and persistence, and Jane Roe for extended picture research; Paul Farrington for the perceptive design of Studio Tonne; and Sam Taylor for his continued dedication and assistance.

I am also grateful to everyone listed below for additional assistance:
ALEXANDRA KEEN, ICON ENTERTAINMENT
ALLARD, KASANDER FILM
AMANDA BOYLE
ANDREW HINTON, CC-LAB
CHIARA, ANTHONY D'OFFAY GALLERY
DILLY GENT
ED FLETCHER, SODA PICTURES
EDDO, C-LEVEL
FLAINE CROWTHER, EMI MUSIC
FEMKE WOLTING, SUBMARINE
GRANT GEE
JANINE MARMOT, HOT PROPERTY FILMS
JENNIE KONG, SCEE
JENNIFER BARTLE, SFMOMA
JEREMY BOXER, DANNY PAYNE, PALM PICTURES
JIM MUNROE, NOMEDIAKINGS.ORG
KEN THAIN
LOUIS FIGGIS, RED MULLET
LUCASFILM ENTERTAINMENT COMPANY LTD.
STEVE MERRETT, LUNCH PR
MARC EVANS
MARK NEALE
MICHAEL ARIAS
NAYSAN MAHMOUDI, LIONS GATE ENTERTAINMENT
NEO
SIMON CALLAGHAN, ATARI
WILD BUNCH UK
ZOE FLOWER, FM FOUNDATION

GLOSSARY

ACCELERATED CINEMA: filmmaking influenced by music videos, with synaesthetic tendencies. Primarily visceral moving image using devices such as rapid montage, and digital effects to alter perception.

ADVANCED MOVING IMAGE: next generation of moving image and film styles and forms evolving out of basic linear cinema. Especially makes use of contemporary digital technologies, hardware, and software to create contemporary viewing experiences that may be non-linear, immersive, and adaptable.

ANIME: Japanese animation.

BLIPVERTS: first used on *Max Headroom* (1984), blipverts are short moving image bursts that present a condensed, rapid collage of information and visual sensation.

CEL-SHADING: used in animation. Cels are individual animation frames. Cel-shading enhances the look of animation to create an illusion of light sources on the subject, giving the animation more depth.

CCD: charge coupled device. A chip that picks up light levels and translates them into electrical inputs to be recorded on DV tape.

CF: commercial film; common abbreviation in Japan for advertisements.

CG, CGI: computer-generated imagery.

CINEMATICS: story footage in computer-games either digital animation or animated by game engine. Also see machinima.

DV: digital video. Also a specific digital video recording format.

EXPANDED DVD: Beyond traditional bonus extras, moving image content using interactive storytelling possibilities of the format.

DVD: Digital versatile disc. Near-ubiquitous format for holding data, and common as an entertainment format for video playback.

EPK: electronic press kit. Collection of video interviews, film, and product extracts often including behind-the-scenes footage, assembled to facilitate promotion of a film.

EXPANDED FILM: historical term for experimental cinema styles.

FLASH: web-based vector animation format.

FMV: full motion video, created and formatted for playback on home entertainment systems.

GAME ENGINE: code that renders the computer game world, and defines how it looks, feels, and acts.

HDTV: high-definition TV.

JAPANIMATION: common U.S. term describing Japanese-derived animation and the common styles associated with this.

MACHINIMA: combining animation, cinema, and machine, machinima is animated filmmaking using 3D game engines.

MEME: a replicating unit of cultural transmission, coined by the scientist Richard Dawkins. Examples of memes include tunes, ideas, catch-phrases, fashions, and behaviors.

MICRO-MOVIES: See nanotainment, but related to moving image only, not interactive experiences. Micro-movies are typically made as short viewing experiences for PDA and mobile devices, and are no longer than a few minutes in duration.

MOD: a modified version or map of a computer game, commonly from a games engine such as Half-Life or Quake 2.

NLE: non-linear editing. Digital editing systems.

NRA: non-representational animation.

NANOTAINMENT: entertainment comprising micro-movies and other short moving image or interactive experiences made for mobile devices and/or quick download and instant viewing consumption.

PROMO: short for promotional video; common abbreviation for music video in the UK.

PDA: portable digital assistants. Handheld computing devices acting as personal information managers, and mobile media devices.

PVP: personal video player.

PVR: personal video recorders. Hardware utilizing hard drive to store moving image, and commonly incorporating software to fetch and download programming for the user.

SCREEN BLEED: modern narrative condition of fictive worlds being uncontainable in one format and narrative, and their ability to live in other media and moving image formats. Screen bleed extends a story into an immersive experience which will include multiple entertainment media and delivery platforms.

SYNAESTHESIA: The word synaesthesia blends the Greek "aesthesis" (sensation), and "syn" (together, or union), implying the experience of two, or more, sensations occurring together.

OPTIC SHIFT: utilizing additional visual streams to allow the viewer different perceptions and viewpoints of a scene. Moving image that utilizes this may be called "slipstreamed."

TIME SQUEEZE: the idea of leisure time being compressed (*Brand New*, Jane Pavitt, 2002). Moving beyond this idea, it follows the development of entertainment formats that take into account this time squeeze and can be watched in compressed or non-sequential form, or in a series of ways according to our time allowance. These formats are "time squeezable."

WEBISODE: episodic web-based drama. Early proponent was *The Spot*.

INDEX

About Time 2　74-5
accelerated cinema　59, 69, 83-95,
　118, 174
Achos Media Jukebox　116
advertiser-funded programming
(AFP)　142-3
Åkerlund, Jonas　93
Akira　98
Alexander the Great　165
Altman, Robert　71
400 Anarchists　38-9
Ang Lee　138, 143, 164
The Angriest Dog in the World　78
animation　97-113
Animatrix　43, 46-7, 103, 128
anime　43, 46-7, 98, 148, 174
Anthony D'Offay Gallery　91
Aphex Twin　88
Apple iPod　116
Avalon　42-5, 46, 48, 53
Avary, Roger　85, 87
avatars　124, 127, 132, 136, 138

Ballard, J. G.　22
Barney, Matthew　153-5, 156
Baudrillard, Jean　43, 45
The Beach　22
Beat the Devil　143
Before Sunrise　109
The Berlin Files　160-1
Big Brother　15
Bigelow, Kathryn　138
The Blair Witch Project　15, 62, 70
blipverts　118, 146, 174
Blood: The Last Vampire　52-3
Blu-ray discs　117
Bodysong　30-3
Borges, Jorges Luis　118, 156
Boyle, Danny　22, 24-5
Bradbury, Ray　57
Bran, Chris　146
BrandClips　146
Brave New World　57
Brennan, John　135
Buena Vista Social Club　29
Buffy the Vampire Slayer　53

C-Level　136
Cale, John　38-9
Caloud, Mike　135
Capcom　64
Cardiff, Janet　116, 160-1

Carnahan, Joe　143
cel-shading　62, 174
The Cello　74-5
charge-coupled device (CCD)
　69, 174
Chuang Tzu　66
Chungking Express　93
cinema verité　74
cinematography　70
Cocoon　118
Cohen, Rob　138
Cole, Jeff　135
Come on my Selector　88
Come to Daddy　88
computer gaming　41-53, 55-67,
　70, 117, 132, 138, 156
computer generation (CG)　59-60,
　64, 99
Cremaster Cycle　152-5
Croft, Lara　57, 59, 67, 124
Crouching Tiger, Hidden Dragon
　138
Cruise, Tom　57
Cunningham, Chris　88-91
Czikszentmiiyalhil, Mihaly　87

Daft Punk　148
Day of the Dead　25
Day of the Triffids　22
28 Days Later　22-5
Dazed & Confused　109
Diaz, Cameron　57
Digital Networking　145
DirecTV　118
Disney　103, 127
documentaries　27-39, 74
Dogma '95　62
Donwood, Stanley　146
Dreamworks　103
Drukqs　88-91
The Duchess of Malfi　73
Dumbland　78-9
Dunne, Anthony　121
DVD　9, 60, 71, 98,
　116-18, 154, 156, 174

Eco, Umberto　95, 141
Eisenstein　88
electronic press kit (EPK)　117, 174
Ellis, Bret Easton　85, 87
Enter the Matrix　43, 46-7,
　132-3, 138

Eschaton　62, 66-7
Evans, Kieron　147
Evans, Marc　15-16
Eye for an Eye　112-13

Fahrenheit 451　57
Fantasia　109
The Fast and the Furious　138
Festen (The Celebration)　166
Figgis, Mike　70-1, 73-4, 77
Fight Club　85, 87
Figures of Speech　106-7
Final Fantasy　64, 124
Fincher, David　85
Finding Nemo　127
Fine Arts Militia　62
Finisterre　147
Fischinger, Oskar　169
Five Angels for the Millennium　169
Flash　78, 174
Flex　91
Flight of the Osiris　128
full motion video (FMV)　64, 67, 174
Future of Gaming　149

game engine　62, 132, 174
Garland, Alex　22
Gee, Grant　34-5, 147
Ghost in the Shell　43, 46
Gibson, William　10, 29
Gladiator　85, 164
Glamorama　87
Glitterati　87
Godard, Jean-Luc　74
Goldeneye　70
Gondry, Michel　85
Grand Theft Auto: Vice City　116
Graphic User Interfaces (GUI)　48
Greenaway, Peter　156-9
The Greeting　169

Hamlet on the Holodeck　57
Hardstaff, Johnny　149
hardware　115-21
Herzog, Werner　74
The Hire　143
The Hire　143
Hollywood　9, 57, 59, 67, 117, 132,
　138, 142, 144, 164
Homer　59, 60
Hooper, Tobe　18
horror movies　13-25
Hostage　143

Hotel　72-3
House with Broken Windows　38-9
Hulk　164
Huxley, Aldous　57
Huyghe, Pierre　128

I Am Legend　22
Ico　138-9
Idioternes (The Idiots)　166-7
Iliad　59
In the Mood for Love　93
interactors　67, 71
Internet　9, 15, 77, 78, 81, 116, 118,
　121, 124, 156
Interstella 5555: The Story
of the Secret Star System　148
Ives, Jonathan　116

Jameson, Frederic　154
Jarmusch, Jim　74
La Jetée　168
Jolie, Angelina　124

Kelly, Paul　147
ki-show-ten-ketsi　53
Kid A　146
Kill Bill　112
Kitakuba, Hiroyuki　53
Kleiser, Jeff　124
Knight, Jake　145
Kojima, Hideo　59
Komar and Melamid　164
Kon, Satoshi　103
Kurosawa, Akira　117
Kworks　128

Lanier, Jaron　116
Leaving Las Vegas　70
Lee, Iara　29
Legend of Zelda　57, 124
Lens Flare　64, 67
Lingford, Ruth　112
Link　57, 124
Linklater, Richard　108-9
Lord of the Rings　47, 138, 164-5
Lucky Star　144
Lumiére, Louis　9
Lynch, David　77, 78, 81

machinima　60, 62, 64, 67, 174
Macromedia　78
Magnetic Rose　98

Manovitch, Lev 70
Mantel, Anthony Dod 25
Mario 57, 124, 127
Marker, Chris 168
Mass Observation 38
Massively Multiplayer Online
Game (MMOG) 48
Matheson, Richard 22
The Matrix trilogy 43, 45, 46-51,
103, 132-3, 142, 165
Matsumoto, Leiji 148
Matsunoto, Taiyou 103
Meeting People is Easy 34-7, 147
Méliès, Georges 9
Metal Gear Solid 57, 58-61, 124
micro-movies 9, 118, 143,
145, 146, 174
Microsoft Media Centers 118
Miller, Georg Burés 161
10 Minutes Older: The Cello 74-5
Miyazaki, Hiyao 109
Mobile Police Patlabor 43
modders 132, 135-6
Modulations 29
Morimoto, Koji 98-9, 103
Morita, Akio 118
Most Wanted and Least Wanted
164
multimedia platforms 115-21
Munroe, Jim 121
Murray, Janet H. 57, 59, 70
music video 83-95
My Little Eye 14-17, 117
My Trip to Liberty City 121

Nakata, Hideo 18, 20-1
Nam June Paik 151, 152
nanotainment 9, 174
Nashville 71
Natural Born Killers 85, 112
Nauman, Bruce 151
Neale, Mark 29
Nintendo 64 70
No Ghost in the Shell 128
No Maps for these Territories 28-9
Noiseman Sound Insect 98-101

Obox 67
Odyssey 59
Olympus goggles 115, 116
The Omega Man 22
Onimusha 64

Only You 91
oral tradition 59, 164
Oshii, Mamoru 42, 45, 46, 53
Otomo, Katsuhiro 98
Owen, Clive 143

Pac Man 57
Palotta, Tommy 106-7
Panasonic 118, 145
Parappa the Rapper 124
Pardue, Kip 87
Parreno, Philippe 128
The Passing 169
The Passions 169
Pavic, Milorad 9
Pavitt, Jane 118, 174
peer-to-peer (P2P) networks
60, 116
Pellington, Mark 145
Perfect Blue 103
Personal Video Players (PVPs)
116, 121, 174
Personal Video Recorders (PVRs)
118, 142, 145, 174
Pinkett-Smith, Jada 132
Pitch Black 138
Pixar 103
PlayStation 67, 81, 116, 118, 149
Portishead 91
President 124
Prospero's Books 157
Public Broadcasting Service (PBS)
107
Pummell, Simon 30

Quake 62, 132
Quicktime 116

Rabbits 76-7
Raby, Fiona 121
Radiohead 34, 118, 146
Raimi, Sam 164
Rashomon 117
Rebel Vs. Thug 62-5
Red Vs. Blue 62
Resident Evil 53
Richter, Hans 169
Ringu (The Ring) 18-21
Roadhead 106, 107
rotoscoping 107, 109
The Rules of Attraction 84-7

Sabiston, Bob 106-7, 109
St. Etienne 147
Salaryman 6 145
Samsung 142
Schumacher, Joel 18
science fiction 41, 43, 47, 107, 168
Scott, Ridley 85
Scott, Tony 143
screen bleed 46-7, 87, 116, 174
Sega 64
Shenmue 64
Shynola 112, 146
Simulacra and Simulation 45
Sky+ 118
Slacker 109
Snack & Drink 106-7
Snake Eater 58-61
software 115-21, 145
Solaris 103
Solid Snake 57, 67, 124
solid-state memory 116, 145
Sons of Liberty 58-61
Sony 77, 81, 116, 118, 149
Spider-Man 164
Spirited Away 109
Spun 92-5
Square 128
Squarepusher 88
Squaresoft 64
Stalker 103
Star Wars 47, 60, 165
Steelwight 62, 66-7
Stone, Oliver 85, 112
Strange Company 62, 66-7
Strange Days 138
Studio 4°C 98
Substance 58-61
surveillance 16, 38, 117
9-11 Survivor 134-5
Sutherland, Kiefer 142
synaesthesia 88, 89, 174
synthespians 124

Takenouchi, Kazuhisa 148
Tanaka, Hideyuki 145
Tape 145
Tarantino, Quentin 112
Tarkovsky 103
Tekkon Kinkreet (Black & White)
102-5
The Telephone Call 160-1
Terminator 3 164

Tetsuo: Iron Man 93
Texas Chainsaw Massacre 18
Thain, Ken 62
The Third Place 80-1
The Ticker 143
time squeeze 118, 174
Timecode 70-1, 73
Titanic 164
TiVo 118, 145
Tlön Uqbar, Orbis Tertius 156
Tomb Raider 57, 59, 124
Toro, Benicio Del 144
Trainspotting 22
Trier, Lars Von 166
The Tulse Luper Suitcases 156-9
Twohy, David 138
Tzukamoto, Shinya 93

Ueda, Fumito 138
universal media disc (UMD) 116
UNKLE 112

Verbinski, Gore 21
Vice City 121
video art 151-61
video cassette recorder (VCR) 118
video on demand (VOD) 117, 142
video games 43, 46, 48,
115-16, 135-9
Vinterberg, Thomas 166
Viola, Bill 15, 89, 151, 169
Virilio, Paul 83

Wachowski Brothers 43, 46, 132
Waco Resurrection 135, 136-7
Waking Life 108-11
webisodes 15, 174
website addresses 10, 45, 77
Weinbren, Grahame 136
Wenders, Wim 29, 74
Windowlicker 88-91
Wong Kar-Wai 93, 143
Woo, John 143
Wyndham, John 22

X-Men 165

Zizek, Slavoj 136